ADVANCE PRAISE

Driven by logic and passion, Cindy has written a book that is a true "how to" for success in the event business. With the most generous, compassionate, and valuable insights, Cindy writes with a voice that is not only engaging but fundamentally educational. In the end, readers will have the information they need to feel informed, supported, and inspired. Every sentence is articulated in a way that invites the reader to keep reading more and more. A must for every event planner's reading.

—ANDREA MICHAELS, PRESIDENT OF EXTRAORDINARY EVENTS
AND AUTHOR OF *REFLECTIONS OF A SUCCESSFUL WALLFLOWER*

Cindy and I have been fellow entrepreneurs since we both started our businesses in the early 2000s. Though we are technically (by definition) competitors, Cindy is one of my most trusted business confidants and truly champions the core value of "community over competition" as a leader in our industry.

A must-read for anyone looking to start their own events business in this fast-paced and rewarding industry. This book is like having a virtual Cindy in your back pocket.

—MARY BAIRD-WILCOCK, CSEP, CEO OF THE SIMPLIFIERS

To be perfectly honest with you, I was intimidated the first time I met Cindy—intimidated by her intelligence, intimidated by her passion, and intimidated by her confidence! These are all characteristics I wish I had. Maybe I had one or two, but never the triple threat that Cindy has.

Then I had the honor and pleasure of getting to know Cindy better by working with her on the ADMEI board, by traveling with her to trade shows, by eating many wonderful dinners with her, and by taking enjoyment in how much she enjoys food—a passion we both share.

I challenge anybody to read this book and not walk away feeling inspired and grateful and have the desire to do more and want more in their own lives. To see what she has accomplished in just a few years shows her aptitude and fortitude for the hospitality industry and the technological industry. And it's amazing to see how she has brought the two together to form a truly authentic and individual company that will last for years to come. Congratulations Cindy on a great career and a wonderful book. All the success in the world to you!

—DAVID E. ROME, CMP, DMCP, DIRECTOR OF SALES
FOR BBC DESTINATION MANAGEMENT, A GLOBAL DMC
PARTNER AND PAST PRESIDENT FOR ADMEI

I've had the pleasure of knowing Cindy for more than a decade thanks to our mutual involvement in MPI. She dreams big and can laugh at her mistakes, and this book is a great resource for anyone wondering if they can make that pivot into the events industry with no formal background. I'm thankful our paths crossed via industry networking!

—NICKIE MORGAN, CMP, CMM, SENIOR EVENT MANAGER FOR NFP

Cindy writes in such a conversational tone. Reading through the pages of how she said goodbye to a lucrative corporate job and instead leaned into the unknown of event planning was as enjoyable as sitting with Cindy over a cup of coffee and personally hearing her inspiring journey towards becoming a top event strategist in our challenging industry.

—FAITH WARD, SENIOR SALES MANAGER OF PALMER EVENTS CENTER

Behind the Red Velvet Curtain bursts with entrepreneurial energy! Equal parts heart and hustle, art and science—this is a great read for anyone wanting to make a pivot into the Event Planning industry. I've had the pleasure of knowing Cindy since our careers began, and her passion and generosity of spirit shine through each page. This book is the perfect floor plan for others learning how to build a successful, sustainable event planning business.

—CHRIS BROWN, CEO OF KAPOW

Cindy is the resident Wonder Woman of the events industry and provides inspiration to an entire generation of up-and-coming event professionals and business owners. Her ability to manage her business, be there for her family, and represent her city makes her a triple threat. She is trailblazing her way to success all while becoming an industry legend and icon. There is no doubt event professionals and business owners alike will find key takeaways from this book in a style only Cindy can deliver!

—AARON KAUFMAN, CSEP, PRESIDENT OF FIFTH ELEMENT GROUP

Cindy's relentless optimism in the face of naïveté, naysayers, and a downturned economy is absolutely infectious—and relatable. If you've ever had those moments of self-doubt, you need this book. It's inspirational!

—KRISTI DEPEW, CWEP, CO-OWNER OF ECLIPSE EVENT CO.

Cindy's book should be a requisite for any entrepreneur starting his or her business, especially in the events industry! It realistically lays out how hard work and determination can create a successful outcome for new business owners. The book includes enough personal detail from Cindy, making it extra relatable and easy to implement for your business.

—LAUREN CHUMBLEY, CMEP, CO-OWNER OF ECLIPSE EVENT CO.

BEHIND THE RED VELVET CURTAIN

BEHIND THE RED VELVET CURTAIN

BUILD AND RUN THE EVENT PLANNING BUSINESS OF YOUR DREAMS

CINDY Y. LO, DMCP

LIONCREST

PUBLISHING

BEHIND THE RED VELVET CURTAIN

Build and Run the Event Planning Business of Your Dreams

ISBN 978-1-61961-854-1 *Paperback*
 978-1-61961-853-4 *Ebook*

CONTENTS

INTRODUCTION

—

I am a planner. This is not just me telling you what I do for a living, even though that would be true, too. I have been known to make spreadsheets for fun. I plot out my calendar in painstaking detail. I never met a list I did not like. I plan for the short-term. I plan for the long-term. I can definitely go with the flow—but only after I have planned to do so in advance, and you can bet I am going to record my results and work those results into a new plan. (Okay, so maybe that is not *really* going with the flow.)

Planning is not just what I do. It is who I am. But some of the best things in life are not planned in advance, like running into friends or falling in love. I am not so rigid that I cannot understand the unexpected may happen or things may change. We should not run away from the serendipity and surprises life throws our way.

One thing I did not meticulously plan was starting my own event planning company. Red Velvet Events was an accident—a *happy* accident.

MY LIFE BEFORE: EVERYTHING ACCORDING TO PLAN

I was the firstborn, first-generation American child of parents who emigrated from British Hong Kong in the early '70s. They chased the American Dream in search of a better future. Ever since I was a kid, my parents drilled into me that I had to get good grades, be a good role model to my two younger sisters, and be the embodiment of an upstanding Chinese-American citizen to show what we stand for. I did all those things, though I had a little rebellious streak. I would always speak my voice if I was not happy with something—a trait not common for a woman in Chinese culture.

I went on to study business at The University of Texas at Austin. I loved my business school, so I planned on following the traditional path they mapped out for us: You go to school, you graduate, you work for five or six years in corporate America, you pop back into school for your MBA, and then you get a job as a manager or a C-level executive. I was prepared to climb every rung of that ladder, much to the delight of my traditional Asian parents. It was so important to them that I get a profes-

sional job after college. Mind you, my parents had a very narrow definition of professional job, which boiled down to three careers: doctor, lawyer, and accountant.

There was no way I was going to be a doctor because I could not stand the sight of blood. I considered a law degree for a moment—literally, I am talking a minute, tops. Once I realized how long it would take to complete school, my reaction was, "Hell no, that is not me. I'm not going to be in school for longer than four years." That left accounting. The summer after my freshman year of college, I got an internship with what was then one of the Big Six accounting firms. I found out auditing and I did not mix well. It was deadly boring, and there was no way I was doing that for a living!

What happened next was the first of three moments in my life when I know I disappointed my parents: I changed my major. I wanted to stay in the business school, and I liked coding in high school, so I switched to Management Information Systems (MIS) halfway between my sophomore and junior year. The hard skills I learned from my new major led me to work at a young company called Trilogy Software right after college. This was the second time I disappointed my poor parents: Instead of accepting a job from a Fortune 100 company—a job which came with a *very* attractive offer—I hopped aboard a tech start-up and even agreed to a much lower salary.

I liked my work at Trilogy. My first position with the company was doing technical presales, which meant I was selling a technical solution to huge corporations when I was fresh out of college. However, we were doing business in the millions, and corporations of that size do not want to buy from a twenty-two-year-old. After a year, I switched positions and became an integration consultant and technical project manager, which made me much happier. The software had already been sold, and our job was to put a team in place to customize and implement the product.

I was satisfied for a while. As several years passed, however, I noticed I was not truly enthusiastic about my work. Technical implementation can be very dry. I liked breaking down processes and discovering how things were run and what needed to be achieved, but the job involved a lot of testing codes and writing documentation on how to use the software. I longed for something more creative, but I did not have a sense at the time of how to make a change to something I was more passionate about.

As it turns out, life has a way of rocking you when you least expect it and in ways you could never predict.

THE 9/11 IMPACT

When 9/11 shocked the nation, I was in New Jersey

working on a project with a software client. The country erupted in complete chaos and confusion. Everything was canceled immediately as the whole country came to a stunned standstill. Naïvely, I drove myself to the airport, returned my rental car, and expected to get on the next flight home to Austin.

The booking agents looked at me strangely. "Ma'am, all the flights are shut down. We have no idea when we'll be back up."

I checked in to the Airport Marriott, thinking it would only be one night. I sat there alone, trying to make sense of the way the world would never be the same.

It was a Tuesday. The planes were grounded until Friday.

Once I was back in Austin, the clients told us not to come back until further notice. After maybe three weeks, I flew back to New Jersey along with the rest of my software consulting team assigned to the project. We wrapped up as much as we could as the holidays approached, and then they decided to hit pause on the project altogether. The company was based both in New Jersey and New York, and they wanted to focus on rebuilding their city. I took a long vacation to Asia, and when I came back, pretty much all the client projects in the upper northeastern states were still frozen.

Before 9/11, Trilogy could not hire enough people because we were landing accounts so fast. However, the ripple effect of the 9/11 attacks had a wide reach, and Trilogy was one of many companies that experienced turmoil and uncertainty during the resulting gridlock. In May of 2002, Trilogy offered certain employees the option of a special, limited-time leave of absence. With this offer, I could take leave with partial pay, full benefits, and the option to come back to a full-time position after five months. In exchange, I would commit to staying in the area and to not working for a competitor.

Trilogy needed to pause and reassess. I realized so did I.

RED VELVET EVENTS IS BORN

When I jumped on Trilogy's leave of absence offer, my then boyfriend (now husband) Scott was shocked I made such a big decision so quickly and without talking to him about it. Before 9/11, I already knew I wanted to switch gears. Then the real soul-searching began. I was not lost or confused, but I was open to new beginnings and wanted to look at industries outside of software. I had never *not* been busy, so I became restless while I was on leave. I thought about going back to school for my MBA, but I had no debt at the time, and taking on a mountain of it did not seem like the right thing to do.

I asked my friends and professional acquaintances for advice on what they thought I should do next. Remember, I am a planner. Part of me could see in advance that Trilogy was not going to be fully recovered after five months. I needed a Plan B.

"Have you ever thought about doing event planning professionally?" a few of them wondered.

The first time someone asked me this question, I was caught off guard. By the second and third time it was brought up, I was floored. No, I had never thought of that! In college, I would always jump at the opportunity to volunteer to organize freshman orientation, mentor dinners, and events with Junior Achievement and the American Heart Association. I loved plotting the logistics, and I kept spreadsheets for everything. I loved being at the center of things. It had honestly never dawned on me that event planning was something people did as a career unless they worked in hotels. That was my only perspective of the industry. I was completely clueless but also completely intrigued.

My aunt was in the hospitality business, working at a major hotel in California, and she introduced me to a corporate planner who worked from home in Houston. When I drove down to meet him for lunch, he listed all the reasons why I should not apply to jobs in this line of work.

I was disappointed he did not take me very seriously, but I knew something he did not know: I was stubborn. I still am. You are not getting rid of me that easily.

"Why don't you talk to my margarita machine supplier?" Scott asked me one day. "I bet he could tell you where to network."

In true bachelor fashion, Scott's house had a pool, and his backyard parties came complete with a rented margarita machine. The supplier turned out to be an entrepreneur named Greg Gordon, now the CEO of PartyMachines. com, and sure enough, he turned out to be well connected. Greg gave me my first helpful piece of advice by encouraging me to get involved with the National Association of Catering Executives (NACE), Meeting Professionals International (MPI), and an organization formerly called the International Special Events Society (ISES), which is now known as the International Live Events Association (ILEA).

These networks were transformative. I soaked up the information I found in these groups like a nerdy sponge. I left inspired, my heart racing as I thought of possibilities and new ideas. Through these channels, I found my first job leads and applied to catering companies. Even though I knew my old job would be waiting for me, I was not sure I wanted it anymore. I longed to explore this new world,

but with no formal experience, no one was willing to take a risk on me. If anything, they were baffled as to why I was on a leave of absence, and they did not understand why I wanted to switch industries in the first place. They all turned me down.

What I failed to recognize at the time is the hospitality industry was hit hard by the post-9/11 economy, too. During the downturn, any events considered nonessential got canceled, and tourism was at an all-time low. Hotels were hurting, caterers were hurting, and morale was nowhere in sight. I did not realize then how that made me an incredibly unattractive candidate—someone with zero experience who wanted to explore the industry but had a lucrative job on the backburner just in case things did not work out.

Not understanding any of this at the time, I took it personally and could not even handle a week of rejections. I know rejection is a natural part of life, and I know most people should hit the pavement for at least three months, but one week was more than enough for me.

I needed to be busy, so I put on my business school hat and turned to Scott and announced, "I'm going to start a business. What do you think?"

As he picked his jaw off the floor, I got to work writing up a business plan and sent it to ten of my contacts from school.

I peppered my friends with the same questions I asked Scott. "I'm going to do this. What do you think? Can you look at this plan and tell me what you think?"

Looking back, I cringe over how naïve and ridiculous I was, but I am a person who cannot sit still. I need to be active. I must be productive. I must make a difference.

My big plan was never about trying to become a successful entrepreneur. I wanted to get event planning experience under my belt, and since no one would hire me, I decided to launch my own company. The job market in 2002 was slim pickings, so I figured I could start the business in a down year and grow from a place where there was nowhere but up to go. Leaving Trilogy to start my own event planning company was the third great disappointment for my parents, by the way.

My new game plan was to get as much experience working events as I could for a full year. When my year was up, I would reapply to event management positions at established companies with a solid portfolio under my belt.

As fate would have it, I never went back.

RETAIL THERAPY

Though I never went back to other event planning com-

panies, my decision to start my own company was not without its detours. After I took my leave of absence from Trilogy and realized no one was going to hire me to do events, I knew I needed to stay occupied. I strategized and zeroed in on where I thought I could find my ideal event planning customers. At the time, I wanted to do fancy weddings and social events because that was the fun stuff I saw in *Martha Stewart Magazine*, but I was twenty-six years old, and I did not have wealthy friends other than my former boss, Joe. I decided to get a job in high-end retail to put me in front of the client base I needed to court.

So much has changed in Austin since 2002, because the only high-end retail business in the area at the time was Saks Fifth Avenue. They did not want to hire me either. They were baffled why someone who used to make a salary would want to suddenly work for ten to fifteen dollars an hour. I did not even put my Trilogy salary down on my application because it was so much higher than what they were probably used to seeing.

They were unconvinced that I was serious about a job in retail, so they asked if I would commit to working through the holiday season. This is the time of year when retail operations are always short-staffed, and it would be forty hours on my feet with no vacation and no days off—including Thanksgiving, Christmas, and

New Years' Eve. The stubborn part of me spoke up and said, "No problem."

I started at Saks in June 2002 in the handbag department, and I learned a number of things from my time in retail. I realized I was a natural seller. They gave me a goal; I beat it. They gave me another; I exceeded it again.

One of the fastest lessons I learned, however, was a disappointing one: The event planning clientele I was trying to court never touched the floor. While they did shop at Saks, they had their own personal shoppers who went straight to the back and used the concierge service. I had no idea. More often than not, the shoppers who did come directly to me were in serious financial debt. I would run their Saks credit card and it would not go through, and they would calculate the bare minimum they would have to pay down to get the card to process.

One of my best shoppers was a woman on a teacher's salary, and I was always trying to convince her *not* to buy another bag. With my business background, I found myself frequently giving lectures on why customers should not buy a handbag on a 22 percent APR credit card. By the time they finished paying off the bag with the minimum payment, it would be a $5,000 handbag and out of style. Most seemed to think this was reverse psychology because they still bought the bag. I have found a number of valid

parallels between this type of shopper and event planning clients who are determined to produce an event they cannot afford. That is not a headache people will want to live with if they do not have the funds.

FUN FACT

My experience at Saks did turn me into a handbag snob! I have so many that I have to make a point to switch them out daily so my husband does not tease me for not using them, and I still love buying them. Do I really need that many? Probably not, but I like the thrill of the hunt, and my exposure at Saks made me appreciate the quality of the design and the uniqueness of a well-made bag. In many ways, my appreciation for the craftsmanship behind remarkable handbags ties into my love of craftsmanship behind remarkable events.

Another lesson I learned from my time in retail was that you cannot do two jobs at once if you want to do one job really well. I officially started the company that would become Red Velvet Events in October 2002, a few months after starting at Saks. I thought I could work my client base during the day and work on my event business at night, but doing both was more complicated than I anticipated. I was not available for event planning calls during the day, I had to ask for time off from Saks to attend networking events, I was not getting in front of the high-end audience like I had thought, and even though I got some great discounts, I was spending more than I was making.

Working retail was a strategy that made sense at the time, and I did learn a lot, but I believe I could have avoided getting sidetracked from my event planning goals if I had just focused on networking during that same period. I had given Saks my word to work through the holidays, so I stayed on until I finally quit in March 2003.

March 2003 was a game-changing month for me. Not only did I quit retail, but I also officially quit Trilogy. During my leave, Trilogy had still been generously contributing 20 percent of my salary and benefits, but now it was time to put my full focus on event planning. I owned my own house at the time, and I realized I had to unload any debt and overhead costs preventing me from being able to spend more time and energy on my business. Scott also owned his own house, and I caught him off guard by telling him I was going to move, but I was only going to move once in the near future.

"What's your decision?" I asked him.

As it dawned on him that I was talking about moving in together, I did tell him it was okay if he was unsure. We agreed that I would move in and pay him rent, which was much cheaper than my mortgage. I took over his home office for my business and was up and running.

FUN FACT

Though Scott and I began dating in January of 2002, I did not meet his family until Thanksgiving of that same year. When I found out Scott invited his parents to come to Austin for the Thanksgiving holiday, I invited my own family so everyone could meet. My last boyfriend and I had grown up together, so I did not realize this was a faux pas. I did not think about how bringing both sets of parents together for a holiday is a milestone, adding a lot of relationship pressure for Scott to propose before he was probably ready.

"So...you're going to do retail now?" my future in-laws wondered when we first met.

I can only think back and laugh at the impression I must have made! Scott's parents had thought he was casually dating someone with a high-paid position at a software company, but now he was in a seemingly serious relationship with someone who ditched a lucrative position to sell handbags.

"See the vision!" I insisted to them. "See the vision!"

WHAT I LOVE ABOUT MY JOB

Even though my event planning efforts started slowly due to splitting my time at Saks, I realized something that gave me the confidence to fully commit: When it came to learning about the event planning business, I was having *fun*.

This experience was not like school, where I had to force myself to crack open a book on law or management. I was

suddenly excited and hungry. I loved the challenge of navigating unchartered waters. I was effortlessly inspired to work. Unlike with past jobs, conducting research and building spreadsheets for my own business did not even feel like work! Since I was still thinking I would only have the business for a year, it was like an exciting project where I could let my workaholic nature run wild and see if I could make the business successful.

One of the early challenges during my debut year was learning the lingo. I remember going to a networking event and talking to two women my own age, but they had been working in the hotel business for at least two years. I was faking my way through these meetings because I had no formal work experience in the hospitality industry at the time, so there was a lot of inching my way near conversations and nodding my head a lot. I heard these two women rattling off industry lingo and wondered, *What's a BEO? What's a CSM?* I tried to inconspicuously jot the terms down in my Palm Pilot. My main strategies at these functions were to be quiet yet engaged, to echo their lingo and agree, and to stuff a canapé in my mouth to avoid elaboration.

This was before Google was omnipresent and before people immediately turned to the internet to research everything. Depending on the subject, information online was not yet thorough or reliable. Through MPI, I tracked down the top books in the field and bought every single

one. I devoured them cover to cover, determined not to feel stupid during my next networking event.

Every day I worked toward building this company, I fell more and more in love. It was the perfect marriage of all my passions. Even before I knew this business existed, I was practically training for a future in it. Both when I was a student and when I worked at Trilogy, I collected all the special event invitations I received and organized them by categories like Creative, Interactive, 3D, or Factual. I kept these in a binder, not because it was some kind of memory book or because I am some kind of hoarder, but because I enjoyed the stationary, the registration process, the personalization, the design, the theme, the possibility—literally everything about them.

I was also a compulsive spreadsheet fiend in school, and I tracked everything. There was a spreadsheet for people I sent Christmas cards to, people I sent birthday cards to, and people who sent me something back. I not only love budgeting and logistics, but I find it to be a genuinely inventive marriage of logic and creative problem solving. I quickly realized one of my strongest skills was taking a budget and figuring out how much money the client specifically needed to raise or charge to break even on a given event. It was like a rewarding puzzle, and I loved seeing how all the pieces broke down and how I could put them back together.

What surprised me was how much the process felt like coding. I used to get this huge high whenever I worked on code and a formula would come out the way I wanted. Taking disjointed pieces and having the vision to know what needs to be done in one area, having a breakthrough about what needs to be done in another area, tuning out the outside noise to laser focus on the problem, and being the agent of change that puts the fragments together and makes magic happen—the challenge left me absolutely buzzing. Putting together a successful event was like building a computer program that could run smoothly and execute an answer in the end. It also uses many of the same skills I developed as a technical project manager, just in a much more creative and fun environment.

I realized early on that this gave me a huge advantage. As Red Velvet Events was taking off, I treated our events like the projects I managed when I worked in tech. On the software side, we tracked everything: the processes we were implementing, who needed to be trained once the process was finished, and who we needed to send documentation to at the end. On the event side, guess what? We track everything: the budget, the vendors, the timeline—everything. My tech background and obsessive love for constructing efficient processes helped me streamline operations for my new business.

WHAT YOU DON'T KNOW *CAN* HURT YOU, OR, WHY WRITE THIS BOOK?

I went through the steps of developing my company from a lark of an idea to the best in its class in our small but exciting sector of the world. Once Red Velvet Events went through its growing pains and found stable ground, I vowed to give back as much as possible. I remember the voices of the people who doubted me. That sting of rejection gave even the most stubborn parts of my personality reason to pause. I want to use this book to save time and heartbreak and to share some of the things I wish someone had told me. I want to share my immense love for this industry, and to help others follow the path they love. I want to be a cheerleader for the dreamers and hard workers, not a naysayer who tells you all the reasons you cannot or should not follow your dreams. I want people to pick up this book and say, "Cindy made these mistakes and she's fine. I can do it, too."

Running a successful, sustainable event planning business is hard. If people look at our social media, it might seem like we only have great days, but that is the public face of what we do. Behind the scenes, it takes a village—and the challenges are rarely captured on camera.

When I first started, it was all about hustling to get clients. If you are brand spanking new to the industry like I was, then you should expect to spend about twelve months

taking on whatever projects you can. You honestly cannot be too picky when you are trying to build a portfolio and a reputation. Just start working on something! I was a one-woman operation for the first few years of Red Velvet Events, so I was taking on everything left and right. Anything that would add another event to my portfolio and another notch on my belt down to the smallest birthday party.

While my strategy made sense, one lesson that took me far too long to learn was that I should not have continued to take on social events for as long as I did. Social events are noncorporate, personal affairs, like anniversary parties and baby showers. These are events with limited budgets, and they did not stimulate me the way more complex corporate events did. Social event clients are disproportionately high needs and frequently are not reciprocal or understanding of why certain boundaries are in place.

I had a vision of building up to corporate events and kept pounding on doors. One of my first big breaks happened at a networking event where someone referred me to a client who needed a planner for a huge, multiday festival. I still have no idea why this stranger thought I could handle a lavish event of this scale. I was still new and largely untested, and I was pregnant with my first child. However, we pulled it off and even won an international award for it.

Some people think that by pulling back the red velvet curtain and talking about the inner workings of my company, I am giving away our secret sauce. I disagree. I want to share important lessons I have learned, not hoard them. I want to be a business owner who refuses to get too comfortable and continually works to better the Red Velvet Events team, our strategies for growing our business, and the industry at large.

I have noticed many newer planners either have no idea how to get started or never make it past the hungry, desperate, and fumbling-around phase I am all too familiar with. My book will help you avoid getting stuck or pigeonholed. Planners sell themselves short in this industry, and undercharging is rampant. My book will help you know your worth. There is a way to make event planning both fun *and* profitable.

In this book, I will detail something I only recently learned: Building and running a successful and sustainable event planning business is about more than the hard skills you can put on a resume. Humility, self-reflection, and the ability to own up to your mistakes are critical ingredients to your future success. There were times when what I did not know *did* hurt me. It does not have to hurt you.

Adding further insult to injury to my parents, I eventually recruited both of my younger sisters to work with me at Red Velvet Events.

"Are you sure you know what you're doing?" my mother asked me.

As you will soon find out, there were plenty of times when I did not know what I was doing. I made my fair share of blunders and even broke a few dozen margarita glasses along the way. However, I am still here, and I am better than fine. I am here to guide you through intimidating terrain, help you thrive, and show you that you too can pick up the pieces.

CHAPTER 1

#LIKEABOSS

—

Red Velvet Events was born before the dawn of social media. When I first cobbled together a business plan, Facebook, Twitter, and Instagram did not exist. There was not even MySpace yet. Nonetheless, social media has been the most important marketing tool for my business, allowing us to become a credible resource and expert in the hospitality industry while spending zero dollars on traditional advertising.

I started this business with only $8,000. The traditional route for advertising an event planning business was to put ads in a magazine like *The Knot* and participate in industry trade shows. Let me be honest here: The main reason I did not run ads was because I did not have the money. I also did not want to stick an ad in the Yellow Pages and be labeled old fashioned.

Some of the $8,000 went toward a printer and laptop, and I allotted another sizable chunk—$2,000, to be exact—for website hosting. No other event planner in my area had a custom website, and the few websites that did exist were clunky, difficult to navigate, and looked like they had not been updated since the midnineties. Coming from the tech world, I smelled an opportunity to stand out from the competition. Some credit goes to my marketing mindset (thank you, McCombs School of Business), but I also fell back on what I knew. The internet was thriving, but plenty of business owners in smaller markets had not caught on to the idea of creating a company website. I am always in a race to be ahead, so I teamed up with a friend who was a webmaster, and we built a company website with a dramatic motif of a Mardi Gras mask to work our way around the fact that I had no actual photos or events to showcase.

Though establishing a website was not cheap on my pitiful budget, it was unthinkable for someone with my background and interests to go without one. I wanted to be an email-savvy, software-driven, and forward-thinking planner. Instead of buying a traditional fax machine, which was the preferred method of contact for hotels at the time, I signed up for an efax.com account. I was always looking for little ways to stay one step ahead. However, one thing I did decide to do the old-fashioned way was networking. I was certain getting face time with experi-

enced and passionate folks in the industry was far more important than putting out ads. With what little money I had left, I printed business cards and tricolor brochures for Red Velvet Events and bought tickets to industry events.

Technology was also a natural way for me to express my creativity. I was eager to wow my client base, and since email was one of the only ways I had of marketing Red Velvet Events, I wanted to make sure I was memorable and brought a smile to people's faces. This was only 2002, so the smartphone as we know it did not exist. The animation software Flash was big at the time, and I spoke with my webmaster about creating interactive online cards. I pat myself on the back for this because it was cutting edge at the time. The first one we sent was a Halloween card in October of 2002. I would email my contacts a link, and a cute little card with a haunted house and spooky music would pop up. A bat would fly one way, a ghost would float another, and a message would read, "Don't be spooked out by your conference budget. Contact us today!" It was cheesy, yet charming.

Because the Halloween e-cards went over so well, I became known for sending out custom-drawn, custom-programmed interactive cards for the major holidays. The e-card business was still new and was more template-based for birthday cards and other celebrations, so this was wildly forward thinking for our industry. People in

my line of work barely had websites, much less original online content creation to engage customers. There are probably a thousand sites that do this today, but at the time, I stayed ahead of the curve. People not only loved the e-cards and the effort that went into them, but they were vocal about their love. I realized quickly anticipating ways to use technology to my creative advantage was going to be a crucial marketing strategy for the company.

Event planning is an inherently social business, and it is an industry where having your finger on the pulse of new trends is a must. Not every trend is going to take off, and not every platform is going to have staying power, but it is in your interest to be on top of the major platforms so you can stay ahead of the next big thing. Staying on top of trends should be a big-picture mission for your company, but it is also incredibly important to keep in mind when marketing your business. There is no way to compete in this day and age without having a social media presence.

Twitter launched in the spring of 2006. My husband was the first to mention Twitter to me, and I was an early adopter. I was always enthusiastic about tracking trends, and I wanted people to know Red Velvet Events as the go-to company when it came to Austin tech events. I was still depending on email and in-person networking for most of my marketing efforts, so you can see how something backed by Silicon Valley that was trendy, free, and promised a massive

network of connections was like a gift from the gods. In the fall of 2006, Facebook expanded from a website just for college students to a website open to anyone with an email address, and I experimented with that platform, too.

I had done speaking engagements on event planning, and I began landing speaking gigs as a social media expert in my field even though I was still figuring it out myself. I already wanted to learn as much as I could, but speaking opportunities lit a fire underneath me. If someone was going to put me up on stage to talk about social media, I better know what I was doing!

The first people I followed on Twitter were other tech geeks, hotels, and big-box businesses. There were really no other event professionals to follow. I seized the advantage, and over time these platforms surged as valuable business-building tools. Social media gave Red Velvet Events a voice, expanded our network, and gave us credibility. I use social media frequently and sincerely, which set both me as a planner and Red Velvet Events as a company apart from the competition.

THE BEST PLATFORMS FOR EVENT PLANNERS

Though the popularity of any one platform is bound to change, social media as a force is not going anywhere. As an event planner, be open to trying out lots of new trends

that come along in tech and figuring out what works for you. Here is how Red Velvet Events uses the following different platforms:

- **Twitter:** Twitter is for links and knowledge building. It is like a big party where you might not know someone, but you want to get to know them. People let it all hang out on Twitter, and they are easy to follow, learn from, and connect with. Unlike platforms like Facebook, Twitter is a place where strangers can easily engage and get into great exchanges, but the pressure is off. It is no big deal if you follow them and they do not follow you back.
- **Instagram:** I call Instagram my "pretty" platform. It is all about the photos! You can see that some of the top influencers on Instagram are clearly using professional equipment and Photoshop, but we agreed we wanted ours to be very natural, mostly shot with our smartphones. It should not look like a glossy page out of *Vogue* because that is not normal! We use Instagram a lot and use it to tell the story of why we love Austin and why we love our jobs. We also use it to offer a peek behind the scenes at events. We focus on connecting, not collecting, so we do not play popularity games where we pay to gain followers. Instead, we let people who love what they see accumulate naturally. This is the most powerful social media outlet for communicating our company culture.
- **Facebook:** Facebook is one of our most lightly used

social media channels. We do not want to annoy people by constantly popping up in people's personal feeds, so we keep it to a minimum. We post weekly quotes for #WisdomWednesday, the occasional blog post, and we will take a minute to highlight a team member who has won or been nominated for an award.

- **LinkedIn:** LinkedIn is our professional face, and it serves to remind people what it is we are doing. This was my first social media account since it housed my online resume, though at the time the website did not have as many social features. I have found it to be a great resource if I want to brag about what Red Velvet Events is doing. Since we are a global company and connect with people from around the world, it is also an excellent place to share articles so others can feel connected with our community.

- **YouTube:** YouTube is a platform we enjoy experimenting with. Though we do not use it as consistently as other social media websites because we do not have an in-house videographer (yet), it is a fun opportunity for people to see us in action as we show off event highlights, produce cheeky yet informative videos, and announce upcoming speaking engagements. We actually think video will become more relevant for event planners in the coming years, so if you have the resources to invest in this area, we strongly recommend it. Be sure to follow our channel as we continue to grow and experiment in this space!

Each platform helps facilitate different kinds of connections, and they also help industry professionals connect with their own voices. There is a learning curve, and boy, did I not understand the best way to use my voice right away! When I first posted status updates on Facebook, I was too casual and was well versed in the crude art of the overshare. For example, "Oh my gosh! I'm so exhausted. Had three client appointments today and I'm toast!" Why on earth did I feel the need to talk about it like that? No one needed to know that—especially not my future clients. There were no great examples to follow in the early days, so I was experimenting and making up my own rules as I went along.

Eventually, I realized my thoughts would make more of a contribution if I focused on how to add value with my communications. I gradually reshaped our online voice and focused not only on promoting the endless number of things we love about Austin, but also on showing why Red Velvet Events was doing so well without giving away all our secrets. As much as I cringe when I think back on the kind of posts I used to make, I also realize that the fact I was using social media at all gave me a head start. I got the oversharing out of my system early, and it was interesting to see other new users make those same mistakes when they first joined. While people's understanding of how to use these platforms has drastically improved in the last decade, I always tell people to spend time listening first.

CONNECT WITH RED VELVET EVENTS!

You can find and follow Red Velvet Events online via the following links and social media handles:

Website: http://www.redvelvetevents.com

Twitter: @RedVelvetEvents

Instagram: @RedVelvetEvents

Facebook: @RedVelvetEvents

LinkedIn: https://www.linkedin.com/company/red-velvet-events-inc./

YouTube: https://www.youtube.com/user/RedVelvetEvents/

SOCIAL MEDIA MATTERS. PLAN AHEAD.

These days, you do not have to come from the tech world to know that social media matters. However, for most tech-savvy pros, there are still lessons to learn about how to anticipate changes to the landscape. Social media is not something you can put on cruise control and assume the way things are now will be the way things are forever.

Because I was an early adopter, people often ask me, "How did you know what was going to catch on?" The truth is that you can never know, but you can be intensely curious. Change is rapid in the digital age, and you should look out for what new things could add value to people's lives. If

you are the type to be skeptical of new trends and write them off in advance, then you should be 100 percent confident your business is 100 percent bulletproof. That is the only circumstance in which experimenting would not be worth your time. Personally, I always want to be first. I do not stick with every fad, but I never want to regret that I did not try.

Claim the name of your business on every new networking platform that comes out! Whether or not you plan on using the outlet right away, you never know if you might want to in the future. I snatched up my Instagram handle when the platform came to prominence, but I squatted on it for a long time before using it. I was hesitant because so many of our events are confidential, and most Instagram accounts at the time were full of selfies. I had no intention of making the account about me, so all was quiet on the Instagram front until we decided to use it around 2014.

When Snapchat first appeared on the scene, I immediately claimed the name RedVelvetEvents and experimented with it for about three months. We had a great run, but it was also harder to find people and harder to measure views in a business where I want to track everything. Eventually Snapchat's competition turned up the heat, and Instagram Stories came out. We already had more of a presence on Instagram, and it was more intuitive for me to use and track views, so I had a clear preference for

Instagram. I also followed a lot of influencers on Snapchat who are big in the hair and makeup design world and had sizable followings on the platform. When I noticed they were posting less and less on Snapchat and more and more on Instagram Stories, I realized it was time to move away from Snapchat. I am glad I tried it, and I still check in on it now and again as they really have the better filters. I also know several event planners who use Snapchat religiously because they have a strong following. However, I learned it is most important to focus on what works best for your individual business—not someone else's.

MAKE IT MEANINGFUL

I love to get feedback from my staff, and I was particularly curious one day to talk to a group of recent new hires about their experience. I took them out to lunch and asked them questions: "Was there anything that surprised you? Anything that caught you off guard?" One of them told me something that caught *me* off guard: "Your Instagram is very authentic." I learned they were comparing the environment they experienced at work to what they thought they would experience based off of Red Velvet Events' Instagram feed. They used the platform to determine if they wanted to be a part of the culture and if it would make them happy. That realization brought everything full circle for me in terms of how we were going to curate our social media presence.

Aspire to participate in a meaningful way by being authentic, and know this requires real thoughtfulness in a connected business world. It is not just about having a way to market to clients. Social media is an expression of Red Velvet Events' mission to be a creative and fun company that values its employees and seeks opportunities to do great work. We will talk more about our company values in Chapter 6, but this mission makes clients think, *Wow, I want to work with them.*

Do not outsource this effort! Engaging with social media is a powerful way to hone your influence when you are growing your company, and it is important to make real connections. Do not simply post for the sake of posting—especially if you are promoting your social media presence on your website. Post wisely by focusing on adding value. If you have tried a platform and it is not working for you, do not be afraid to move on like we did when we stopped using Snapchat and deleted all references to it from our website.

GIVE SOCIAL MEDIA THE TIME IT DESERVES

As social media savvy as younger generations are, I have been surprised to find many have never thought much about using online networking platforms from a business perspective. They struggle with it because they are not sure what is and is not allowed at first. I have been

working with our younger team members on asking some basic—yet important—questions. "Is this something that would attract a potential client? Will this make us look more attractive? Does this give something away that we don't want to reveal to our competitors?"

On Twitter, we focus more on female entrepreneurship, Austin entrepreneurship, and event planning in general. I tweet thought-provoking facts, I tweet when I am at a conference, and I retweet content relevant to that message. I have over eighteen thousand tweets, so it is safe to say I use Twitter a lot!

Social media can be part of a marketing plan, and for Red Velvet Events it is our marketing initiative. In 2014, we hired a dedicated marketing coordinator who had previously interned with us—and who just so happens to be my youngest sister, LeeAnn. At fifteen years my junior, she is staunchly in the millennial demographic. Together, LeeAnn and I set goals and discuss strategy, and it is fascinating to me to see the differences in perspective. If anything, she is more conservative about posting frequency on Instagram.

"It's not like Twitter," she tells me. "You have to post sporadically or millennials will think you're too noisy!"

Before adding LeeAnn to the team, I managed all the

social media postings myself. That is the reality for most new entrepreneurs when they launch their own event planning business, but luckily it is much easier now to plan and schedule posts in advance.

As referrals are the linchpin of Red Velvet Events' success, we see the landscape of digital networks as a way to create experiences worth sharing and harness the potential of word of mouth. After all, word of mouth is the original social media. These platforms are a powerful opportunity to do something today to stay ahead of tomorrow. Use this power wisely!

CHAPTER 2

#RTFM

(READ THE F#@%ING MANUAL)

———

NERDS ARE COOL

I was called a nerd more than a few times when I was younger, but little did I know back then that understanding the ins and outs of technology and software would be major assets in a nontech career like event planning. When I started Red Velvet Events, my technical skills set me apart.

I have always been curious when it comes to all things tech, and that curiosity drives me to be in the know. Whenever there is a new platform or solution on the market, I start playing around with it immediately. I always want to try new things at least once, and I get a major thrill when I feel like I am an early adopter of something new that is

about to become huge. I was an early Excel user when I was still in my teens. When a tech client told me about Google Drive soon after its 2007 debut, I quickly worked out what it was and how to reap its benefits so I could use it to collaborate with other clients. By 2008, I knew that a cloud could be found in places other than the sky, and I used Dropbox for all of my documents as soon as it was easily affordable.

FUN FACT

The title of this chapter uses the acronym RTFM, or Read the F#@%ing Manual. This is an acronym today's geek culture apparently knows well, though admittedly I had to look this one up! I am notorious for using acronyms. Something I brought over from my time in the tech world is giving each team member a three-letter initial for in-office communication. These are usually based on our first, middle, and last initials, but sometimes we have to get creative if any are too similar.

Not only do I use acronyms, but I am also notorious for misusing them. Sometimes people will write back because they cannot figure out what I am talking about. I love writing <EOM>, which means "End of Message", which I started doing when I just want to write in the email subject line and not the body of the email—almost like a text. "What is be/c?" someone once asked, and I realized I thought that meant "because" and had been using it since junior high school. I also use a (triangle) for "change" because of chemistry. This is neither an acronym nor is it something I am using incorrectly; it is just another thing I cannot stop using even though other people do not understand what I mean! Some of my most-used acronyms are listed in the glossary, found at the end of the book.

I cannot emphasize enough that being super tech-savvy was not the norm for the event planning industry. Not even close. When I first started Red Velvet Events, most of my competitors did not even have a website. You had to haul out the phone book and scour through the fine print to find them. It is sometimes hard for millennials to imagine, but most businesses were run by adults who did not grow up with the internet and were very slow to learn to use it and understand how it could help their businesses. It was the norm for event planning business cards to have a name, a phone number, a fax number, and that was it.

Naturally, I decided to be different. A website seemed like an obvious thing to make for my business, and I was so excited that I was going to be one of the few event planners in my market to have one. The website URL and my email were printed on my very first Red Velvet Events business cards (see fig. 2.1) which were custom-designed by my graphic designer contractor, Will. If Twitter had existed at the time, my handle would undoubtedly have been on there, too.

FIGURE 2.1. MY FIRST RED VELVET EVENTS BUSINESS CARDS.

FUN FACT

When I first began event planning, Red Velvet Events was called something totally different! My very, very first business cards boasted the name "Austintatious Events" as a play on the word *ostentatious*. I was so proud of what I thought was clever wordplay...but when people looked at the name, they could never pronounce it! I tried to stick with the name for the first year, but I made the change before I even celebrated my first year in business. I am reminded of this part of my past whenever I run into my good friend and industry peer Janice Foster. She loves to remind people, "I have known Cindy since she was Austintatious Events!"

I could not afford to have a separate traditional phone line to support a traditional fax machine with my meager budget. But some clients (like hotels) still used faxes, and I was not about to miss out on the opportunity to work with them. I had heard about digital faxes, so I did some research and signed up for a service right away. Suddenly,

I could scan a forty-six-page document without any hassle, and when I received a fax, it would appear in my inbox already converted into a PDF. This blew people away. From day one, our business has never had the need for a single file cabinet. All our paperwork has always been stored electronically.

From the earliest stages, my desire to be tapped into the digital world was my differentiator. What I found pretty normal about technology was not normal knowledge for others, and I needed to capitalize on this difference. Technology not only made me more efficient, but it also made me stand out and appear more attractive to the tech community.

I also discovered I was able to talk to people about technology and demystify it. Within two years of starting Red Velvet Events, I was invited to speak at a business about my tech skills and digital business strategies. It was a casual lunch, and the attendees in the office gathered around a conference room table. They had no idea who I was other than some lady who was a geek for all things technology and software. I was a little nervous at first, and I was talking a little too fast for my own good. But once I got a lay of the land after a few minutes and they laughed at my first joke, I felt like I was in control and relaxed. Feeling nervous until I get a laugh has actually become my modus operandi for all of my speaking engagements to this day!

These talks became more and more frequent as event professionals kept asking me to teach other businesses about relevant online platforms. Suddenly I was considered not just a teacher, but a *good* teacher.

For the past decade, business associations have been inviting me to speak about Google Docs (now known as Google Drive). The very first class I gave on the subject was in New Orleans not long after the platform launched back in 2007, so it was not nearly as widespread as it is now. I aimed the talk at small businesses, wanting to convince them that it would work for them the way it worked for me. I was passionate about the fact that it was a free and easy way to get organized and collaborate without having to constantly email files back and forth. I like to think talks like mine contributed to the popularity of the platform, though the fact that Google Docs was both free and user-friendly probably did not hurt either.

Red Velvet Events was also one of the first companies to use the cloud for documents. In the past, hotels would also give me folders with floor diagrams, meeting room specs, and menus for events. My part-time assistant would scan these files and save them to an electronic folder. First it was saved to a hard drive, then to cloud services (first with Box, then Dropbox) when I needed more storage and a better way to share files.

Because I come from tech, I did not fear new technologies would crash or get hacked the way others around me did. If big companies like Google and Amazon were willing to bet their data security on these databases, why not me? Why not follow in the footsteps of giants? Thankfully, hotels finally came around to technology, and we now regularly share electronic files instead of paper files. Red Velvet Events has a dedicated team member who saves the files, dates them, labels them according to our naming configuration, and puts them in our database of vendors and suppliers.

FUN FACT

Something I carried over from the tech world was an effective approach for naming files. When you code, everyone has to be on the same page in terms of how you label and check in files. This system has been invaluable for developing Red Velvet Events' files and procedures. We have different ways of saving contracts, invoices, receipts, and so forth to keep things organized, and every program we touch has a four-digit ID. There is even an entire internal document at Red Velvet Events just on how to save and name files.

If you are not using Dropbox yet, you are missing out on a ton of useful features. I will never again have to deal with file attachments being too large to send by email because I can just share a Dropbox link instead. The convenience also makes it much easier to take days off and

go on vacations. In 2013, I took seven weeks off to travel through Thailand, Hong Kong, Cambodia, South Korea, and Hawaii with my husband and two young kids. Seven whole weeks! With Dropbox as our company server, we did not have to be tied to our physical office since I had my laptop with me. We could get work done from anywhere and no longer had to stress over whether someone could help a client while we were away.

Staying ahead of technology helps us work more efficiently and live a rewarding life alongside our careers. To this day, I am still invited to speak about my social media skills and how companies and event planners can benefit from being more tech forward. The bottom line is that technology is huge, so make sure you are literate.

SEE YOU ON THE DOWNSIDE

I would be lying if I said there were no disadvantages to implementing new technologies. For starters, my obsession with staying ahead of digital trends is not a value that is widely held in this industry. Most event planners are savvy about trends when it comes to things like music or incorporating the Pantone color of the year into a color palette, but not necessarily about technology. On top of that, most people are resistant to change regardless of whether they are technophiles or technophobes, so not all employees and clients are ready and willing to

adapt. Some people do not trust that the software will work properly; others struggle to even log in.

We do not want to force something on clients that would be disruptive to their normal process. We want them in the best possible collaboration mindset, and clients typically favor what they are accustomed to. That said, it is often worth checking in with traditional clients to see if they are happy with how they are receiving their files and communications and mentioning there are more efficient work platforms if they are willing to try them. I remember one client who initially refused to transition to Google Drive, requesting that we email Excel files instead. A couple of years after we started working together, the client wished there was a simpler way to do everything.

"That's exactly what Google Drive is for," I said.

Some people get set in their ways and forget to look around with a curious mind to see if there are improved ways of doing things. They need a little nudge.

I learned another disadvantage the hard way: Change is not always an improvement. As someone who loves to learn about the newest developments on the horizon, that realization was sacrilege. But the truth is, being tech-savvy also means experimenting with new things that are littered with kinks and bugs.

Picture this scene: I meet these guys at a South by Southwest event, and they tell me their new platform is the PowerPoint of the future. I had already heard of this new software and knew it was one to watch. The way they were going to revolutionize presentations really did sound like a dream come true. Everything would be in the cloud, companies could make slide templates to build custom proposals in record time, and there were advanced analytics—what more could our team need? I was determined that this was the next way for us to be a differentiator in our industry.

It was not until after we implemented this technology that I discovered the pitfalls, and there were quite a few. I did not anticipate that the system would became slower and slower with each new slide we added. It was just dragging. We would click Save, then wait in agony for changes to be confirmed. The inefficient process reminded me of the long-gone days of dial-up Internet. On top of that, it was difficult to customize and generally awkward to use. I was frustrated. Our team was frustrated. Everyone begged to go back to PowerPoint. To be fair, the company had just launched, and it is likely they have since fixed all of these issues. Nonetheless, it was not the right technology for our team at that time. We barely used it for a year and a half before we gave up. I was disappointed because I had gotten invested in the idea that it would be a game changer, but what worked in theory did not work in reality.

You will find that as your business grows, people are used to working a certain way and are reluctant to change their habits. A company needs to jump together to soar. Since this letdown, there have been multiple times when I have tried to introduce new technologies to our team and been rejected.

SLACKERS

Even with the most efficient and hardworking team, not everything will run smoothly. Three years ago, I wanted my company to use Slack, which is a cloud-based communication program. The resistance was fierce. You would have thought I was asking our team to give up their firstborn. Meetings were full of eye rolls and moans because no one wanted to spend time learning how to use a new platform. I really thought we were going to be early adopters and it was going to transform the way we communicated, but the employees won. Slack was out.

I now realize what went wrong. Not only was I not effective enough in explaining why Slack was a program our company needed, but I was not even using it properly myself. I told the team it was for random chatting and posting articles, but I should have explained it was a replacement for the work-related communication we did on Google Hangouts or instant messaging. They did not adopt it because they did not want to chit-chat or post content. I

did not fully understand the platform before implementing it, nor did I get the team to try it out beforehand. I just went straight in and expected everyone to enthusiastically jump on board. Needless to say, that approach failed.

Last year, a client told me Slack had made some major improvements and encouraged me to give the program another try. I was curious, of course. At the time, Red Velvet Events employees were all using different instant messaging platforms (e.g., Google Plus, ICQ, Google Hangouts, iMessage, etc.), and I hoped bringing Slack back would streamline company-wide communication. The second time around, everyone loved it! The timing was better, some of the new folks who had joined Red Velvet Events were more readily experimental, and I had improved my understanding of how best to sell innovative ideas to our employees. We now have 100 percent adoption of the platform within our current team.

FUN FACT

Something else I have trouble selling our team on is not my ideas, but what they call my "Cindyisms." Most of these are hashtags I like, but some are sayings that I think are idioms in the moment, but I wind up botching them. These are phrases like:

- Hindsight is 50/50! (Translation: Hindsight is 20/20.)
- Drumbell, please! (Translation: Drumroll, please!)
- My ears are itching! (Translation: My ears are burning.)
- You never want to hurt the hand that feeds you! (Translation: Don't bite the hand that feeds you.)
- You can't see the trees through the forest! (Translation: You can't see the forest for the trees.)
- Get a leg on each side! (Translation: Straddle both sides of the fence.)

There is an entire board of Cindyisms in my office, and our team uses it to remind me that some of the expressions I use simply do not exist!

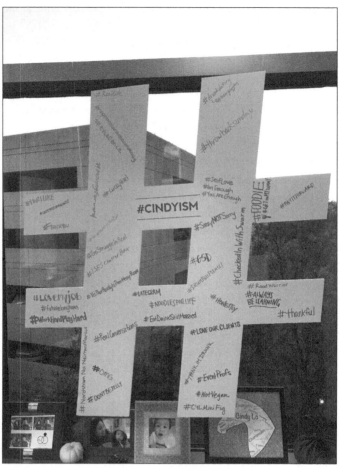

FIGURE 2.2. THE CINDYISM BOARD

LEADING CHANGE IS A PEOPLE SKILL

I learned a great deal from the struggles with the new slide presentation software and the initial introduction of Slack. I realized that if I wanted to run a tight and tech-savvy ship, I needed to verify the merits of the new software and to

understand it so well that I could sell it to our team in the most appealing and exciting way possible. I also learned that implementing change as a leader requires empathy in order for the change to be readily embraced.

Now, my executive leadership team and I thoroughly experiment with new technology first before we take anything to the team. If I feel a program I am trying out could add value to the company, make the business more focused and efficient, or help solve any problems we are facing, then and only then do I present that program to the entire team. This is followed by another period of experimenting that lasts from six months to a year. If the feedback is positive, then we adopt the technology as part of the company.

Red Velvet Events is still in the process of figuring every-thing out. Thanks to hiring a new director of operations, we recently finalized our official standard operating pro-cedures (SOP), which every successful business needs to help its employees handle sales, supplies, and clients. We have had a working copy of a core set of procedures since 2013 when Christa H. joined the team as my executive assistant and right hand. But we only just finished nailing down all the nitty-gritty details to the point where we feel like we could put a bow on it, thinking about everything from the most frequently asked questions to the things people would never think to ask about.

Our SOP can still be revised, and I constantly ask our team for feedback. What works for a small team might not work for a big team, and vice versa. A specific strategy for one year might run out of steam the next. Our methods are constantly reworked and updated, and while there are always challenges with coordination, getting comfortable is getting behind. If we notice a team member is not following an SOP, we investigate why. Is it because they do not understand it? Is it cumbersome? If they want to implement a change, then they need to bring it up so we can roll it out. Everyone has to follow the process or chaos ensues, so I am OCD about it for a reason!

TEAMWORK MAKES THE DREAM WORK

Early on in the business, I was pregnant with my first child and simultaneously struggling to run the company. My husband suggested that if I wanted my business to grow, I needed to hire people to help me out. I adjusted my business strategy, and the decision to build a team also made it possible to take on more events.

The key to a successful event planning company is building a modern, creative, and tech-savvy team of driven individuals devoted to constantly improving their methods to get the best possible outcome. You need a group that is not afraid to experiment and is willing to stumble and fall,

learning from methods that do not work on the journey to finding the methods that do.

If you are not tech savvy about computer technology, hire someone who is. This can be hard to get across to aspiring event planners because so many people focus on the creative side of the business. Pay close attention to the hiring process, because who you hire determines how your business will push forward.

When we were starting out, we would ask interviewees to rate their computer skills on a traditional grade scale of A, B, or C—A being an expert user and C being a beginner. One person we interviewed gave himself a B-minus in Excel literacy. I hired him, thinking he would be fine with minimal training. When I saw him looking for a calculator because he could not sum in Excel, I realized that his B-minus was my idea of an F. My kids use PowerPoint, Keynote, and Excel at school, so my thought was that if they could do it, then working adults should catch up. Technology is the future, after all. But not everyone has the same background, and it turns out that many people think they know how to use Excel because they can go to A24 or B26 and type numbers into cells. They do not understand that plugging in numbers is just data entry. Because of this misconception, having people self-evaluate their skill level was not as useful as we originally thought.

Now, we administer computer literacy tests to give us a more accurate picture of whether or not a prospective employee knows the basics of PowerPoint, Word, Excel, and email communication. If a promising candidate is a great culture fit but is not very computer literate, then I at least know in advance and we are properly prepared to train them.

When hiring employees and delegating responsibility, your role in the business will inevitably change. I used to plan everything for Red Velvet Events. When we grew and started selling more, however, I moved on to other things. That meant trusting that the team I hired would plan events similarly to the way I would. While my employees do not own the business, I want them to act like they do. If I am working with a group that understands the importance of staying on top of trends and ahead of the competition in a culture of constant change, then I have the trust I need to get on with other endeavors.

CAREERPLUG

Red Velvet Events recently upgraded the software tool we use for hiring and interviewing candidates. In the past, candidates filled out a Google Form, after which we would manually look at it, critique it, and update a master spreadsheet of applicants. As the company grew, our operations team could not keep up with the sheer

volume of applicants using this system. Not only was the process labor-intensive, but we fell behind on getting back to people about their status.

FUN FACT

Here are some of Red Velvet Events' hiring data by the numbers:

- In 2016, we received over 750 resumes for only 9 available positions.
- From January to July of 2017, we received 419 resumes.
- Out of those 419 applicants, 48 made it to the first screening.
- Of the 48 who made it to the first screening, 29 went on to a face-to-face meeting with team members.
- Of the 29 who had a face-to-face meeting, 6 made it to an interview with me.
- Of the 6 who interviewed with me, 3 received offers.

The operations team approached me about streamlining the process, and I agreed because I am all about efficiency. They found a website called CareerPlug and presented it to me. There is a monthly fee, but now everything related to the application process is under one umbrella. Not only is the job candidate's information stored in one place, but we can easily see where each person is in the process. Are they still being screened? Have they made it to the next level? Are they waiting on an answer? I swear this is not a paid plug (pun intended) for CareerPlug, but between this new platform and the fact that we now have a dedicated

team member just for careers, the process is now much more orderly and efficient.

Not many people make it through the funnel because our applicant pool is huge, and because we have to be smart about our time, we can only look at those who we think would be happy with our culture. But the software makes it easier to find the right people and to prioritize responding back to every job seeker so they know where they stand.

THE DEVIL IS IN THE DETAILS

When I look at the industry, I notice that businesses similar to mine that started around the same time have disappeared from the event planning scene. Why did Red Velvet Events survive?

It is definitely not because we did not make the same mistakes as others. There were times when the future of our business was under serious threat, but we pulled together and came out stronger. I think it is because we were better at learning from our mistakes and modifying our approaches accordingly. I noticed that some other event planning businesses that started out at about the same time as Red Velvet Events did not adjust and kept making the same mistakes. Eventually, some of these companies quietly disappeared from the scene.

Some peers in the industry have called me out for being "too OCD" about the processes we use. Along with being called a nerd as a kid, OCD was another term that was thrown at me a lot. I knew these names were supposedly negative things, but I decided I was not going to take the name-calling personally. If anything, I wore it like a badge of honor. If being OCD or nerdy means caring more than the average person, then I think it is a compliment. Besides, who is someone else to accuse me of being overly fussy and detailed about things? How are they so sure their preconceived idea of how much fuss and detail is required is exactly the right amount?

Some of the folks in the industry who were critical of my structured processes eventually closed their businesses. I have come to realize my attention to detail has been key to Red Velvet Events' success. Running an event planning company is not a career path for people with low standards for excellence who want to do the bare minimum and coast. Embrace your obsessive side if you want to create a great experience for your clients!

KNOW YOUR NUMBERS, KNOW YOUR WORTH

If you want to pursue event planning as something that is more than a hobby, you must have the financial literacy to understand how much it costs to run that business. If you are not good with numbers, make it a point to find a partner who is.

I often give talks to wedding planners, and I am always surprised at how little they charge for their services. Here is an example I gave to a group of new and aspiring wedding planners to highlight the relationship between work and pay:

If someone is aiming to earn $40,000 a year as a wedding planner and charges $2,000 per wedding, how many weddings do they need to plan to reach their goal?

To answer this question, remember that this wedding planner has to hire and pay an assistant, so they do not keep the full $2,000 fee. Some of the aspiring wedding planners I was speaking to were shocked when they did the math and realized that it would take around thirty weddings a year (remember there are only fifty-two weeks in a year) just to reach the target salary. Only then did they realize they absolutely had to charge more if they wanted to build a sustainable business.

The problem, however, is not that these planners do not want to make more money. It is that they are *afraid* to ask for more. This is an industry that attracts a lot of people with giving personalities who want to do something beautiful and make others happy. This is also an industry that attracts women in significantly greater numbers than men, and women are often hesitant to ask for more. It is understandable that so many undercharge, but as a

business owner, it still throws me every time because I can see that it is never going to work.

I get the hesitation because I have been there. When you first start out, you are working on establishing your reputation and proving your value, so you do need to undercharge. It is about being realistic about your position on the food chain. I practically gave away my services away during my first year of business. But once you are known in the market and people think, *Wow, she's good*, then you will have the solid support and recommendations you need to switch gears and start charging what you deserve.

That is the step that so many event and wedding planners do not have the confidence to take, and that is something I wish I had the confidence to do sooner. *Oh my gosh, if I charge what I really want, they are never going to hire me*, you might think. But the worst that can happen is that someone says no.

For planners who have a solid portfolio and are ready to take that leap, I recommend biting the bullet and asking for more money as soon as you are confronted with a particularly challenging opportunity. I am talking the kind of event where there are red flags that it is going to be a difficult endeavor. You know you will have to work your tail off, and those are the jobs that are never, ever worth it if you are not making enough money. Jobs like

that can end up costing you in unexpected ways—your time, your energy, and maybe even a little of your sanity. If the client rejects your fee, then you safely dodged a bullet. They were probably looking to work someone to the bone for a bargain at your expense. If they accept your fee, you have crossed an important career milestone. It is a win-win situation.

MAKE YOUR MARK(UP)

When I had just launched the business, I remember doing some research to learn what event planners typically charged. It was difficult. Openly discussing service charges was even more of a taboo back then than it is now. I attempted some math on the back of a napkin, pretending I knew what I was doing when, in reality, I had no idea. I managed to calculate that I would have to charge thirty-five dollars an hour to make a decent living for a year. While thirty-five dollars an hour sounds pretty good, my working hours only came from booked events, and it is not nearly enough if you only work twenty hours a month. I calculated that I would have to plan forty small events a year to earn what I needed. Because I was terrified to lose clients, I said yes to everything and spent three years undercharging and trying to make a name for myself.

Over the next six years, though, I got more references, changed the company pricing structure, and took on lots

of smaller events. There were larger events in between, some of which we only had eight weeks to plan. I was proving myself and gaining clients' trust. Our rates went from thirty-five to fifty to seventy-five dollars an hour until an outsider finally convinced me to raise my figure to what it is now.

Part of my struggle during these early years was that I refused to mark up resale for the longest time. Let's say I rented a bunch of tables and chairs for an event. If the rental company gave me a 10 percent discount, I used to give the client a 10 percent discount. In the event planning industry, it is standard to mark up between 5 to 30 percent depending on what the item is. Marking up is not only standard practice for the event planning industry, but also for nearly every industry where goods and services are sold. If you walk into a Walmart to buy deodorant, you know you are paying more than the wholesale price the retail chain paid Procter & Gamble. If you buy Nabisco crackers on an airplane, you know you are paying even more than you would pay in a Walmart. Thanks to a captive audience with limited options, airlines enjoy an extremely high markup rate. You might grumble about it, but you are probably not going to grill the flight attendant to find out what the airline paid Nabisco.

When I decided not to mark up, I was not necessarily trying to be the cheapest person in my field. I simply

thought it would make me different. I finally reconsidered in 2010. Red Velvet Events is an Austin Destination Management Company (DMC), which means nonlocal meeting and event planners can hire us as a third party to coordinate an event in the city we are most familiar with for their clients. I was chatting with a DMC in another market and asked her about markups.

When she learned I did not mark up at all, she was stunned and said, "I don't know how you make your numbers."

This was not the first time others had suggested I mark up, but that specific comment made me pause. The truth was, I was not meeting my stretch goals and my business was not growing. We began marking up in 2011, and our revenue doubled. When I sent out a survey to our clients, they all assumed I had always marked up! It turns out that not marking up was never a selling point to begin with.

Guess what? I did lose a few clients after marking up, but I soon realized they were the right clients to lose. I needed to change and pivot our target audience, and I needed to be able to communicate our new rate with confidence. The worst thing to happen during this transition was that a few clients told us they were looking for a cheaper option. No one ever said, "You're ridiculous. You're charging more than you're worth." We knew our rate was proportional to the quality of our services, and they knew it, too. Our rates

were high in Austin (and some might even say they still are), but nowhere near the highest in the event planning industry overall. We charge far less than event planners in cities like New York or Chicago, but our quality is just as high. I probably would not have been able to say that before, but I am glad I have built the confidence to say that now.

FUN FACT

This might not be a fun fact so much as a scary conundrum for today's event planners! Right now, special events clients want transparency and have been asking to see raw invoices of what we pay our wholesalers and suppliers. Possibly because of past history with other companies, clients often feel the markup is too high. When this happens, I tell them they need to question whether or not they value the convenience and service we are providing.

Clients hire Red Velvet Events because we are more than order-takers. We are a creative events agency with a DMC arm, we provide peace of mind, we handle logistics, and we transform their vision into reality. So yes, it makes sense for us to mark up because we are a for-profit business. When other event planners ask me if they should mark up, I say yes! I do not have a problem line-iteming what the corporate client pays for, but I do have a problem handing over supplier invoices—particularly because there is a small subset of unethical operators who will ask for proposals with line items, only to turn around and go direct to our suppliers. It is an increasingly sensitive topic in today's industry.

#TOUGHLOVE

—

MAKING NETWORKING WORK

I have met a lot of people who hate networking. They dread the thought of walking into a room full of strangers, attempting to infiltrate into cliques that have already formed while trying to come off as natural, comfortable, and confident. *I'm supposed to just walk up and say hi? What if they are deep in conversation and think I'm rude? What if no one notices me—or worse—chooses not to? Isn't that the worst kind of rejection there is?*

As intimidating as it can be, networking is crucial—especially for a business like Red Velvet Events. We have never put out traditional ads. Instead, we built our entire business on referrals. If we want to find events to plan, we need to seek them out! We make ourselves seen and heard, shake hands, introduce ourselves, and really get to know people. We put in the time, effort, and energy.

There are right and wrong ways to network. I would never want our employees to stop the first person they come across and say, "Hey, do you want to buy an event today?" We are not used car salesmen. My advice is to take a genuine interest in people and make meaningful connections. Get to know them personally. Find out about their backgrounds, their interests, and their career paths. It all comes down to relationships. At the end of the day, people want to work with people they like.

I once became Facebook friends with someone I met at a networking event who had seen me speak publicly. Once we connected on social media, she invited me to do a speaking engagement. Sometimes it is as simple as making new friends. If the word "networking" freaks you out, do not use it. To show you how naïve I was, I did not even know the term networking existed before starting Red Velvet Events. Instead, think of networking as widening your circle of business friends.

Because networking is so important and there can be a lot of fear, think of it as "tough love networking." If I am tired at the end of the day, the last thing I want to do is go out and put on a big smiley face and act all cheerful to try to win business. But that process is exactly how Red Velvet Events wins business. So, I give myself a tough love pep talk and say, "It's been a tough day, but let's do this. The team is relying on me to help us hit our stretch goals."

Breaking down the process makes networking look and feel a lot less intimidating. If there is an event from 6:00 p.m. to 8:00 p.m. and you are shaking in your stilettos at the thought of going, you should set a clear time limit for yourself and say, "I am going to this event, and I am going to go from exactly six thirty to seven thirty. If I am not having a good time, then I will leave when my hour is up. If I am having a good time, I will stay to the end."

Give yourself an easily achievable goal, such as connecting with two new people. The objective is not to collect a stack of business cards. This is not baseball card trading! Wear your favorite outfit, your cutest shoes, your lucky necklace—whatever makes you feel confident.

An important tip is to be realistic. It is unlikely you will find lifelong business connections at your first networking event, but if you challenge yourself to meet one person, then two, then maybe you will come across someone you can picture becoming a "work friend." Remember you are attending events in search of meaningful connections, not to collect a pile of business cards that will collect dust in your desk drawer. I have noticed a visible difference in business between the times I am feeling a little lazy compared to the times I make an effort—whether that means slapping a smile onto my face and attending a speaking engagement or staying on the ball with social media, which also counts as networking.

I am not going to deny it: Obligatory mingling is not always smooth sailing. I have had some duds when I go to networking events. We are all extroverts in this business, but that does not mean you will connect with everyone. Small talk can be awkward and forced. No one likes talking about the weather, so it is a good idea to think up a couple of conversation starters ahead of time. I usually try and get people to open up by asking simple questions like whether or not this is their first meeting or if they came along with anyone. If I have been to a few meetings already and my new acquaintance has not, I will take the time to introduce them so they do not have to feel like they came and did not meet anyone besides my talkative self. I know that feeling all too well. You just want to crawl into a corner instead of doing the thing you came to do.

If it is my first time at a meeting, it is not a bad idea to attach myself to someone in the know—but only if they are willing! If you sense things going downhill, make a polite exit and do not take it personally.

"I am going to check out the cheese plate," you might say. "It's so nice to meet you, Joanne. Here's my business card."

Then skedaddle. The cheese plate (or the bar) is always the answer.

BUILDING A SUPPORT SYSTEM

It takes a lot of courage and practice to walk into a room and start a productive conversation, but the more you do, the better you become. I did not know a soul at my first networking event, so I dragged my best friend along. She is not in the industry, but she lived close to the venue and gave me much-needed moral support. In the past, I never had to do much networking because I was lucky enough to get a job straight out of college. I had no clue what to expect at the first networking event. I went in, business card in my shaking hand, and I walked out feeling disappointed. I thought to myself, *Wow, that was tougher than I expected. Am I really going to be able to call this my next career move?* It was not easy making my own connections, but building a business is not easy. Luckily, I am notoriously stubborn. My name slowly began to be recognized. I would receive unexpected emails asking about our services. It began to look like networking could actually get me somewhere.

My experience has been that almost all of these events have some sort of low-budget activity to get people engaged and involved. Sometimes we color; sometimes we mix drinks. At my very first networking meeting, we were tasked with making hats out of paper bags. We were all event professionals, so naturally we were all creative and good with our hands, right? Wrong. The activity literally made me question whether I was in the right industry.

I looked around in awe at everyone else's intricate designs. Mine, however, looked like a kid's botched school project. I love the logistics aspect of planning, and I love coming up with ideas, but the DIY thing is *not* my strong suit. What matters, though, is that I did it. I took a step outside of my comfort zone, got involved, spoke to people, and had a funny story to tell afterwards.

This is where I met Damon Holditch, CSEP, CERP, the owner of Marquee Event Group who led the event. He was so friendly and outgoing, and we chatted about his bright pink shirt that matched his hot pink company colors. He urged me to sign up for a committee, so I got involved with the Austin chapter of the organization now known as ILEA right away. This spontaneous decision ended up being a valuable career move, and I became a committee member. The association helped me get to know people and offered me an inside look at the industry, and it was the exact kick-start I needed. Red Velvet Events even went on to win several awards with the organization.

I am so glad I did not walk out of that first meeting and that I met this encouraging man in the pink shirt and the cowboy hat. I always say, "I remember Damon's help with that. I am going to help others if I make it." He recently retired, but Damon has made a huge difference in the Austin special events scene. He was one of the first on board and helped form the ILEA Austin chapter, and I

felt so special when he recruited me. Being inexperienced and coming from the tech world, I had no business being at ILEA. But I said yes to Damon and took advantage of it. Getting involved with ILEA allowed me to work on events for their fundraising and membership recruitment and helped me gain my bearings.

Under my leadership, ILEA Austin won a chapter award for the first time in the membership department. While our chapter is thriving now, at the time we were a scrappy little group that was only a few years old, so this was a big deal. The Dallas chapter was the place to be if you wanted to be somebody in the events space because it was huge by comparison, but I wanted to work in Austin. I recruited enough newcomers to our little chapter so that we were recognized for having the largest number of new members. You never know what opportunities might come up when you choose to get involved.

FUN FACT

I formed the networking group Austin DMC Roundtable in 2009 after learning about a similar group in San Antonio. I attended a few San Antonio meetings where DMC competitors gathered monthly to talk about industry issues. I decided Austin needed one, too, so I reached out to members of the Austin-based DMCs who were actively involved with the Association of Destination Management Executives International (ADMEI) to see if they wanted to come together. I totally forgot I came up with this initiative until someone reminded me last year!

Another gathering I formed combined networking with my love of technology. When the iPhone first came out in 2007, meeting planners were still very uncertain of how to use smartphones. I was on the Technology Committee for Meeting Professionals International (MPI) Texas Hill Country Chapter, and we wanted to find ways for people to better connect one-on-one with their mobile devices without having to wait for the annual meeting. Most people were just using the phone as a phone, but I was using it for everything and wanted to show others how to adopt the many features. We formed "High-Tech Happy Hour" meetups where we would gather at a bar, and I would actually talk through the uses as if I were an Apple Genius. I have to thank Debbie Farnum, CMP, for being at almost every single one of these High-Tech Happy Hours.

MORE ADVENTURES IN TOUGH-LOVE NETWORKING

The people I network with could be divided into three groups: fellow UT alumni, tech-based contacts from my past job at Trilogy, and others I have met in the hospitality industry. When I met with former Trilogy colleagues and they learned about my current line of business, they

often jumped at the chance to offer me advice. At first, it was hard to accept their input. "You do not even know my industry," I would think. "Hospitality is so different from software." But I realized that some of the advice they gave me was actually applicable.

Looking back, it is clear that the entrepreneurial and sales-minded people at Trilogy offered perspectives as business owners. A number of them had been through the same challenges I was facing. Why would they not have good advice? They were just trying to keep me from making the same mistakes they made while I was still trying to figure things out. I realized that I needed to be more open-minded and take advice from everyone. When professionals in your network offer constructive suggestions that can make you feel a little defensive but ultimately offer solid insight, this is another type of tough-love networking.

One of my lucky breaks was joining a CEO support group. This was a group I did not even know I needed, in part because I had no clue such a group existed until another business owner invited me into the fold. He saw I was trying to grow Red Velvet Events and reached out, and there was no cost other than time and vulnerability. Now that I have been a member for over ten years with the same group, I could not imagine my business without it.

In the beginning, I felt like an outsider. My company was

generating the lowest revenue out of all of the other members, and I did not have the same business acumen, so I felt like an impostor. I was a junior CEO in a room full of seniors. They were incredibly welcoming, but they knew they had made an exception for me to be there. But there was a common thread that tied us together, and that was the fact we were all going through the valley of death in one form or another, eagerly trying to grow our businesses into stable companies.

Here is how the group works: We come prepared to talk about one high and one low both on the personal front and the professional front. In return, the group follows the Gestalt method which helps you find solutions not by dismissing your methods, but by fostering empathy. Instead of telling a person what to do, which can be distressing, group members share personal stories about how they solved similar problems in their own businesses. Even with this method, I felt attacked at first. While they were offering constructive feedback, all I heard was what needed to be changed. What I did not understand at the time was that my lows, which felt dramatic and impossibly stressful, were common problems in business.

All problems in business boil down to two things: people and cash flow. One issue I brought to the group concerned a problematic employee. "Fire them," the group said. My guard shot up; I immediately became defensive. "You do

not understand my business. It's harder than you think," I thought. My instinct is to help people achieve, so firing my employee without giving them a chance to work it out seemed abrupt and unethical.

But then a client came to me and said, "Cindy, I understand you're trying to take your business to the next level, but do you mind if I give you some feedback?"

I encouraged them to lay it on me, and they said that they really liked me and wanted to work with me, but they were not going to continue with Red Velvet Events if they were assigned the same program manager. The client explained that this team member did not reflect the Red Velvet Events' culture or values, and another client came forward with a similar complaint.

"Oh my gosh," I thought. "I was so busy making excuses for every mistake, I wasn't listening."

When I fired that team member, the rest of our team breathed a collective sigh of relief. They actually thanked me. I was blown away by this. If they knew things were bad, why did they not tell me? As it turns out, they did not think it was their place—especially because the team member in question was one of my most senior employees at the time. I realized my CEO support group was offering a perspective through the lens of their own experience. In

order to grow, you sometimes need an outside perspective that will take you out of your comfort zone.

My CEO support group also advised me to change the Red Velvet Events pricing model so I would not lose money. Specifically, this was when they were suggesting I mark up (which I detailed in the previous chapter). Again, I became defensive. What did these software experts know about pricing events? But, again, they were right.

The wake-up call came from my husband. The company was still not making great money, and he said that if I did not stop the ship from sinking, he was going to pull the plug because I deserved to be making more. The way he saw it, I could either work a lot less and do it for fun without worrying about making money, or I could work my butt off and reap financial rewards. What did not make sense, however, was working myself to the bone just to lose money or make very little.

I finally experimented with marking up. Thankfully, it worked. It worked so well that we needed to hire more employees. When we did a survey for client feedback after the price change took effect, they wrote that they thought our new prices were what we had been charging all along. After all the stress and fear I had about raising my prices and potentially scaring away clients, the irony

was not lost on me that they did not experience any grief over the change.

Learn to take constructive advice you do not want to hear from people who have been there. It is not easy to recognize and own up to your own mistakes—especially because you might not even recognize certain efforts as mistakes. But your business can only grow if you do. Learning to have a more open mind made my involvement with the CEO group a transformative, empowering experience. Everyone supports each other because, one way or another, everyone understands what everyone else is going through. You might not always like the advice you are given, but you can learn to value and apply it nonetheless. Red Velvet Events would not be where it is today without their support. Tough love works wonders.

MAKE CONNECTIONS LAST

I believe in karma—in the idea that what goes around comes around. Don't believe in karma? Think of this aspect of networking in terms of little things adding up. Networking has a ripple effect.

In the beginning, my networking actually had two purposes. The first was to meet people and learn everything I could. The second was because I had nothing else to do. I was brand new and only had a few events—how else was

I going to spend my time? I needed to be actively doing something, and going to these networking events helped me qualify my time. "Look! I am spending two hours making connections and learning the lingo. I am working!" And I really was. Red Velvet Events grew because people started remembering our company name and emailing me out of the blue.

The great thing about seeing networking as work was that it became easier and easier for the experience to feel productive, and it was way more fun than the usual job-related tasks most people experience. In the words of my husband, "If it feels like work, you're doing it wrong." It is all about the mindset you adopt.

To me, networking is not just about showing up and collecting some free food and business cards. It is about bringing value to every new person I meet. If I connect with someone at a networking event for the first time, I hope they feel comfortable enough with me after chatting for a bit to share something they are pursuing. Whether they are looking to get a promotion, to start their own business, or to write a novel, I want to find an area I can help them with even if it has nothing to do with planning events. I want to bring value to the table whether someone asks me to or not. Wowing people naturally builds trust and helped me establish a solid reputation so people wanted to recommend Red Velvet Events down the line.

The best methods for keeping in touch with your new contacts depend on how busy and dedicated you are. Because Austin is small yet booming, I love meeting as many people as I can and having physical, face-to-face encounters two or three times a week. But there is not enough face time in the world because people are so busy. Social media platforms are great ways of maintaining contact virtually.

When I meet someone for the first time, I try to remember one thing about them and write it on the back of their business card, and when I get home I put that information into Salesforce.

Met Chelsea at May 10th happy hour. She loves French bulldogs.

That makes it easy to remember the person and recall the conversation. I previously used Microsoft Outlook to store information about my contacts, but that did not last very long because they had a cap. As Red Velvet Events grew, Salesforce became an invaluable tool. Not only can the platform handle my current personal list of over eighteen thousand contacts, but it allows me to share contacts across employees.

When I meet someone new, I also offer all of my social media handles and welcome them to stay in touch virtually. If I know Chelsea is bidding out an event soon, I will

reach out right away. If not, I will leave her alone for a bit. I do not want to leave anyone with the impression that my only goal is to sell Red Velvet Events to them. The sell is important, but it needs to be organic, not pushy or forced.

It is also important to pay attention to when your contacts switch companies. Just as you want potential clients to follow your business growth, you want to follow others' career growth, too. I knew an industry leader who changed jobs a good eight times since I started Red Velvet Events. While she was moving from place to place, we were a constant she remembered. While we could not necessarily help this client in all eight of her roles, you never know when someone will need an event planner.

Eventually, I developed a deep curiosity about networking thanks to the people I was meeting. Looking to sell yourself is counterproductive and will make networking feel like work, but focusing on honoring others as individuals first keeps things fun and fruitful. By joining organizations and groups bonded by common industries or goals, you can learn from others who have already been in your shoes and became stronger for it. Put yourself out there. I promise, you will not regret it.

CHAPTER 4

#FAIL

THE GREAT MARGARITA FIASCO

Everybody makes mistakes. I do. You do. Even the most successful CEOs in business do. A major part of growing and maturing is learning how to accept responsibility for failure. I will be the first one to admit that when I was first starting out, I had a tough time owning up to my mistakes. I might have been able to admit partial fault, but a little voice in my head would spread the blame. Now that I have been working professionally for more than twenty years, I am a lot better at analyzing and identifying when my actions are at fault for a misfire or when there really were other factors involved.

I have also grown to see mistakes as unavoidable learning experiences on the rocky road to building a business. They teach you fundamental lessons in a

faster way—albeit a more brutal way. And by brutal, I mean catastrophic.

I will never forget the disastrous nonprofit event I organized as one of my first events. The client informed me that, due to a tight budget, the event was going to rely heavily on parents and volunteers. I nonetheless accepted quickly, thinking it would be a breeze and a great way to gain more experience. Fast-forward to the day of the event. It was late afternoon and the venue was a high school gymnasium. One very important detail is that this was an enclosed space with a set of double doors right in the middle instead of having doors by the basketball hoops. It was like a grand entrance.

We wanted to surprise everyone, so the guests remained outside while we set up, and we kept the doors closed for our big reveal. Up to that point, everything was going well. The volunteers came through and picked up the food. We had custom menu cards at each seat. I was so proud of myself. I decided to have the volunteers stack the margarita glasses I rented in a tier formation onto a pair of side tables. I wanted it to look like those fancy champagne towers at cocktail parties where champagne is poured into the top and flows into all the others. I thought about the possibility that someone could bump into the table, so I decided not to stack it more than a few glasses high.

The room looked incredible, and we were ready to open

the double doors for the grand reveal. And now here is something I did not predict: The sudden opening of the doors created a huge suction of air. The blast caused the side table on the right to collapse, then the left. The towers of margarita glasses came crashing down, shattering and splintering into a thousand shards in the span of a few seconds.

I was completely and utterly mortified, and I could not go into rescue mode fast enough! Soon, other mistakes became horrifyingly clear to me. I did not have a broom on hand. There was no way I was going to charge the client for the broken glassware when the tower idea was my doing, so I was going to have to pay for the damage. I did not have any backup glasses. I did not even have any plastic cups. We managed to clean up the mess and salvage a few glasses that people reused, and the event went on after the setback, but that experience was a fiasco. Though I have come a long way, this particular client has yet to rehire Red Velvet Events since that fateful day.

After the calamity, I wracked my brain to figure out what I did wrong. Could I have put the glasses in simple rows instead of arranging them in a tower? Yes, but while that might have kept some of the glasses from totally breaking, that would not have stopped the tables from collapsing. Should I have predicted the change in air pressure? Maybe, but I am not a physics expert.

I finally realized the problem. I overstepped and took on a line of work that I did not know how to do. I am a project manager and a creative idea conceptualizer. But I am neither a bartender nor a caterer, and I tried to do too many things that a bartender or a caterer would probably have foreseen as recipes for trouble. I assumed that line of work was easier than it really is, and this was the universe telling me to stay in my lane. If I had stuck to a behind-the-scenes role and either hired caterers or delegated responsibilities to experienced volunteers, the embarrassing catastrophe might have been avoided.

This was not my finest hour, but I can definitely say I learned my lesson the hard way!

GOT MILK?

I was pretty naïve in some ways when I had my first child. For starters, this was still in the early days of the company and I remember insisting to clients that they did not have to worry about me delivering early around the time of their event. Oh my gosh! You cannot control a pregnancy. If the baby wants to come, the baby wants to come. Luckily, both of my babies wanted to stay cooked (Is that a Cindyism? That means I had a scheduled inducement for both children.), but this same naïveté about how bodies work during motherhood did cause problems later.

FUN FACT

Because I had an inducement for both children, I got to pick their birthdays! Both were due around the same time of year. With my daughter Sofia, I looked at the calendar and counted backward from the start of the South by Southwest festival, picking a Saturday. It was a date that would give me enough time to pop her out and be ready for the big event. When my son Holland was due around the same time of year, I picked a Wednesday so I could be out of the hospital by the weekend (assuming a no-complication delivery), which I later realized made the kids exactly two years and fifty weeks apart in age.

A potential new client learned of Red Velvet Events through a referral, and I went to meet with them shortly after giving birth to my daughter. Well, I was brand new to breastfeeding, and I did not have time to nurse Sofia or pump before the meeting. I knew breasts engorge and get hard when this happens because they are full of milk, and I knew this was considered to be a bad thing. But I figured since engorgement was not painful for me, I would be okay as long as I did not bump into anything.

I went to the meeting and did my sales pitch, and then the client asked me about my baby. You may or may not be aware of this, but it is not uncommon for nursing mothers to spontaneously lactate when they think about their baby or hear a baby cry because the brain releases oxytocin. This was something else I did not know at the time. When the client asked me about my child, I immediately

started leaking. This is Texas, and it was ninety degrees Fahrenheit, so I thought I was sweating at first. But then I realized what was happening and quickly excused myself.

When I got to the restroom, the entire chest area of my shirt was drenched. It had completely soaked through the lining of my bra and through my shirt. Luckily, I had a suit jacket to put on, but now I was leaking *and* sweating in the Texas heat. I went back to the client and wrapped up the meeting quickly, apologizing for needing to excuse myself. The client was polite, and I managed to close the deal. I learned that—just like a baby—the milk will come when it is ready! I also learned that I needed to be more aware of any other fun and potentially embarrassing surprises motherhood had in store for me.

RED FLAGS

A few years ago, we tried to reshape Red Velvet Events to make management more effective. My CEO board had long been telling me to hire a leadership team, and we had quietly been looking for two or three years. In the back of my mind, I knew it was the right business decision to make, but did I ever make it a true priority? Not exactly. I was always conservative on how much we spent on payroll, and hiring leadership meant more money because they would naturally come with higher salaries. I had also insisted on wanting a small team when I first started the company,

so I resisted the idea of a bigger team even though there were signs it was time. I was stalling.

I was also reading a lot of management books, and they all championed grooming from within. Sarah had been there for a number of years, and she really wanted to be head of operations. We identified some people internally to promote, but they were not interested—and looking back, I can see why. I did not really groom anyone so much as I simply tried to promote them. One team member in particular stands out because she was wise to recognize she was not ready for a management position. I was pushing it because she was a rock star, but she knew she was too young and had more to learn.

At this same time, Red Velvet Events was growing at a rapid pace. We were the biggest we had ever been, we were closing more business than we could handle, and we got more and more bogged down as time went on without the right leaders in place. Because of a health issue (which I will discuss in the next chapter), I committed to finding someone and fast-tracked it. All of a sudden, I was racing through stacks of resumes and thinking, *Could this one be the leader? Or this one? What about this one?*

I hired a candidate whom I had never worked with prior, but whom I knew of and who came highly recommended. Sarah and I conducted interviews with her, and we both

gave the thumbs up. She was a tremendously talented and experienced planner, and we felt so lucky to snatch her up. But things turned out to be too good to be true. Red flags presented themselves as we went through training, indicating the new manager might not have been the right fit, but I thought I could fix any problems that arose. I was wrong.

This new manager had many virtues. Not only was she a phenomenal planner, but she was extremely loyal, which is something you cannot train. She was driven and hard-working, and she jumped right in with an event where I had been left hanging when someone backed out of a commitment, and I needed a lot of support. She was extremely committed and clients loved her. But this was her first time as a true manager, and she had been coached to have a more authoritative leadership style than what was right for our culture.

The worst thing about this problem was that I thought I could quickly address any issues, but my team had a different perception. Our team accepted me as a leader, and they accepted Sarah as a leader, but they did not accept my sudden rollout of this new person as my second-in-command. They thought I was playing favorites and allowing her to behave differently than everyone else. The whole point of bringing her on board was because we wanted to grow the team, but strong team members

actually left because the work environment had become unhealthy. People will quit over negative experiences with management, and I did not learn their real reason for leaving until it was too late.

When I look back and reflect on this period, one lesson I learned was that being an awesome planner does not always translate into being the most effective leader. Another problem was that I did not nip the issue in the bud fast enough. Despite seeing warning signs, I was too casual about my belief that problems could be resolved in good time, unknowingly isolating our team in the process.

What really struck me was that I not only knew about the problem and did not properly fix it, but I had already experienced the problem more than once before. This was the third attempt to bring in a manager from the outside, and all three managers had nearly identical issues. That was another big oversight on my part. I thought, *Wow, did I really not learn my lesson the first and second time around?* Making a mistake is sometimes inevitable, but I should have tried harder not to repeat my mistake. The second time it happened, shame on me. The third time it happened, there is no excuse!

Work relationships are a lot like dating. The red flags bugging you on the first few dates are not going away, no matter what excuses you make to avoid addressing them.

So what if he chews with his mouth open? That won't bother me, and if it does, I can change him later! That never, ever works. Be honest with yourself. Pull off the Band-Aid or pull the plug. If I had been honest with myself and raised concerns earlier about this manager, we could have avoided a lot of frustration and turnover from team members who felt defeated and undervalued.

I also take responsibility for failing to effectively communicate my plan about the reshaping of Red Velvet Events to the people who needed to hear it the most: our team. I never clearly articulated that I was looking for the right tier of talent to form an executive leadership team so I could delegate some of my responsibilities. Because I never articulated my vision or needs to the team, it should not have surprised me that they felt uneasy about communicating their frustrations with me. The executive leadership team worked in my mind but caused chaos in reality.

TAKE TIME TO REFLECT

Retrospect is remarkable. Not only can time help you see what you were doing wrong, but it can highlight the consequences of what you failed to do at all.

Looking back, I cannot tell you how much I wish I had hired a dedicated salesperson other than myself sooner. In our company, the salesperson is responsible for respond-

ing to—and hopefully winning—event proposals. Once again, stubborn little me thought I could do it all. I ignored the advice of my CEO support group as well as the advice of my husband for almost three years. *I'm a good enough salesperson*, I thought. Plus, the software sales team I used to work with made so much money, and I did not know where to look to find someone we would actually be able to afford. I was just so worried about the money, and I did not think adding a new person to fill the role would generate that much more business.

My husband recognized I was in stubborn mode and threatened to pull the plug if I did not hire someone. In our fifteen-year history, my husband and I have had two serious conversations where he threatened to shut down Red Velvet Events: The first was when he insisted I raise my prices, and the second was when he put his foot down after three years of asking and flat-out told me I needed to hire a salesperson once and for all. We finally hired someone when the company was just shy of celebrating ten years, and I am happy to say that I was wrong—big-time wrong! The difference in the growth and efficiency of our business was huge.

CRIMES & MISDEMEANORS

South by Southwest (SXSW) is a major film, music, and interactive festival and is a huge event for Austin's

economy every year. Red Velvet Events has been doing events for the conference since we started in 2002. One year, a major company hired us to produce an event and requested we install an oversized banner on a downtown Austin building on a short timeline. We were required to pull a permit because of the size of the banner, and I delegated that task to a team member.

On the day of the event, city officers approached me while I was on site. They were checking to ensure codes and regulations were being followed and asked to see our permit. I called the team member in charge of securing the permit and asked her to send it to me. She asked me if I could stall them. *Uh-oh. This is not good*, I thought. I let the officers know our permit was with another employee, and they wrote me a ticket. It was inconvenient, but I figured it was not a big deal at the time because I could just track down the paperwork later and get the ticket dismissed.

Unfortunately, I later learned the person I delegated the task to did not notify me that the permit was denied because of our tight time frame. There was no permit at all.

Still, I thought I could simply explain what happened.

But when I went to the courthouse, they told me, "You understand a banner violation is a Class C misdemeanor, right?"

What? I was in shock. A misdemeanor C is for things like petty theft or bail jumping. I had never received anything worse than a speeding ticket in my life. I begged them to just let me pay the fine and keep it off my record, but the best they would offer me was reducing my fine in exchange for a few hours of community service. I was beside myself. I just could not believe I was getting a misdemeanor over installing an oversized banner!

Technically, I could have sent my employee to take the fall, but I think that would have been another major fail. As the owner of the company, I believe it is my job to take ownership. This was my event, and I should have followed up with our team member about the permit instead of assuming it was safely locked in the office. I did three days of community service, which was challenging and pushed my boundaries. I do volunteer work all the time, but when you do community service for a misdemeanor, you do it alongside others who have been charged with the same class of violation. It was an eye-opening experience that reminded me I am very fortunate, and I felt grateful for the experience in the end.

LET IT GO, LAUGH IT OUT

Here is something that was a radical revelation for me: All of the negativity and frustration that comes along with failure? Let it go.

Years ago, I had an exceptionally mean client whose actions I let get to me more than I should have. In the middle of one of my many rants to Scott about the client, he cut me off.

"Look, it's been three weeks, Cindy," he said. "Let it go."

This jolted me. Did he not enjoy talking through my work problems? I learned that he did, but it turns out he does not like hearing about the same problem on a loop for weeks on end. He was right—I did need to let it go. Not only that, I needed to find a way to do something about the problem instead of endlessly dwelling on something and dissecting every detail.

Most mistakes are not career-ending or reputation-ruining blunders. Failure offers powerful insights you could not have otherwise learned. I am writing this book to record my mistakes and lessons so others can benefit from them—and so I can look back and laugh!

Here is an important truth I want to share: **When it comes to problems, *fix* them—don't *fixate* on them.**

Be the project manager of your own thoughts. You have to think about rough experiences enough to learn from them, but do not dwell on them because you will literally get depressed. Give yourself time to feel upset, embarrassed,

and angry, and give yourself a timeline to determine lessons learned. Then move on. What is most important is how you bounce back.

Turn your failures into stories you can laugh about with others. It is better than therapy. This industry is stressful enough as it is!

CHAPTER 5

#IWANTAUNICORN

———

BALANCING ACT

Balance is not impossible to achieve. What is impossible, however, is attempting to pass off another person's balanced lifestyle as your own.

One of the questions I am asked most frequently at speaking engagements—particularly from college students—is, "What is your typical day?" I usually answer that there is no such thing, but I will go on to detail a full day. I am a morning person, and I enjoy looking fit, so I choose to wake up around 4:30 a.m. to work out before getting the kids ready for school. I typically have back-to-back appointments from 9:00 a.m. to 5:00 p.m., though I might start as early as 8:00 a.m. if that is the only free time left for a last-minute appointment. If I am free in the evenings, I pick the kids up myself. If not, I will ask the nanny to get

them. Nighttime is for catching up on any unfinished work or getting a head start for the next day.

Oftentimes, the reaction to this is surprise and disbelief. When they hear my husband and I both work fifty to sixty hours a week, they think it is too intense. For them, it might be. I could easily get away with working forty hours a week, but I am driven to take Red Velvet Events to the next level. It takes discipline, but this is my normal. My life is calendared down to the smallest detail. But here is the thing: I like to be busy and get things done, and I am lucky to be able to spend time with my family and take wonderful vacations while working a job I genuinely love.

RECOGNIZING NEEDS

The first step to achieving balance is recognizing exactly what all of those needs are. They will not always be clear, and they are never exactly the same for everybody. As I see it, event professionals are constantly seeking a balance between these interconnected factors:

- Client needs and company needs
- Company needs and employee needs
- Career needs and home needs

How exactly you balance each set of needs is relative to where you are in your career and what your goals are. Are

you working for a business or running a business? Are you early career, midcareer, or late career? When you are just starting out, there is no room to be picky. Take on any client whose needs you can meet, regardless of whether or not they are a good fit. Even if it is unpleasant, you will gain experience, add to your portfolio, and perhaps gain more insight into the types of people you do not love to work with. As you progress, you can begin to prioritize company needs and choose events that better fit your philosophy.

Every once in a while, you will find yourself with what I call a PIA—or a "Pain in the Ass" client. When I was starting out, I had one client who was extremely high-maintenance. I not only put my life on hold to be available for him 24/7, but he was mean. Working with him was neither fulfilling nor gratifying for me. Quite the opposite. He was emotionally draining, and his attitude took a toll on our team. I need our team to be refreshed to work on other events. We were not making enough money nor getting any additional leads from him. That kind of business is not lucrative because it costs us more than we make. When he came around later with another event, we said we were booked to avoid working with him again. I did not want to hurt his feelings, but ultimately, I was not happy having him as a client.

No matter how much a client tests your patience, you have

to learn to deal with them in a respectful and professional way—a task that is not always easy. Recently, we had a client who was making impossible requests that were far out of budget. They wanted me to personally manage the project, for example, but I had already made it clear that it was a busy time of year and I was traveling. I explained that I had a strong and capable team available to help, and if they were not happy with the people we were assigning them, we would have to withdraw from the event as they were preventing us from doing our job the way we do it best. That is eventually what we did, and I can only hope they appreciated my transparency.

Some clients find it hard to express their requests and listen to your conditions. Others assume that because the money is coming out of their pocket, they are entitled to treat you any way they want. Many clients are frustrated about the amount of money we are spending and try to redo our plans to make them cheaper. At Red Velvet Events, we have been quite fortunate to have only ever had two clients whom I considered firing on the spot because their behavior was so out of order and because they treated our team in an unacceptable way. We do not have a standard protocol for any of these types of situations. We handle them on a rare, case-by-case basis.

High-end and high-maintenance clients are inescapable, but you will learn to assess which ones are worth

working for. I have one client who usually calls me at the last minute, so the team ends up working at least eighty hours a week for those events until execution day. This means this client has enough trust in our team to know we can pull off an event on short notice. One big difference between this client and the others I have mentioned is that the opportunity is worth it. Not only does the client pay well, but their requests are incredibly creative and satisfying. The needs are high, but the work is the exciting stuff that made me want to become an event planner in the first place. I would not want to lose this client to a competitor, so I make the exception of taking on last-minute events with him.

There are clients who challenge you in a positive and rewarding way, and there are clients who make your work impossible. Part of the journey of finding a healthy balance is assessing the client's needs as well as your own to assess whether an event will be worth all the effort you put in to make it happen.

HERE'S TO YOUR HEALTH

Your health is something you cannot ignore. I do not smoke, I only drink socially, and I work out. I *do* love to eat—I will eat all the cheese in the world, and I love ribeye because of the fat, not the cut. (But in exchange, I work out twice as hard!) For the most part, I am very healthy,

but in recent years I have had some health scares that threw my life and work off balance.

GROWING PAINS

When we were on the hunt for my second-in-command, Sarah and I were the only two executives in the company. Because we were growing so fast, we were also always hiring another planner, another operations person, or another team member of some kind. We were also having some turnover, but otherwise our revenue was soaring, and Red Velvet Events was doing really well.

While all this was happening with the business, I was experiencing this pain in my chest. I did not know what it was but knew something was off, and my concern over this pain was the reason why I fast-tracked our leadership team search. I went to a doctor and described what I was feeling. He took an X-ray and could not spot anything. In fact, he insisted that because I could not really describe my symptoms, it was probably just a fluke. But as time progressed, the pain got a little worse. I sought a second opinion.

An important aside to know for this story is that I have breast implants. After I had my son Holland, I had a mommy makeover. I was very thin growing up, but after my second child, I had weight I just could not lose no

matter how much I worked out. My doctor told me my belly would never be the same. Because I gained so much weight in my stomach, a muscle in my belly broke. I like to be fit, but I admittedly stopped working out during my pregnancy—and I had little to no self-control! *Now is the one time when I get to eat everything!* I thought as I chowed down on McDonald's. So, some of my baby weight was preventable, but I obviously did not care at the time. I gained fifty pounds with Sofia, which is a lot for a girl who only used to weigh 110 pounds! With Holland, I only gained twenty or thirty pounds because I had not lost all of my baby weight from Sofia.

After having Holland, I was back to my normal size, but I still had a bit of a belly.

While event planning is not as vain an industry as modeling, people do place a lot of value on appearances. When I was working on site for an event, the client said, "Oh my gosh, I didn't realize you were expecting again!"

I corrected them and said I was not, in fact, pregnant.

FUN FACT

After I was mistaken for being a couple months pregnant at that event, I burned our uniforms. Go big or go home, right?

I was pretty much against plastic surgery at the time, but then I went to a holiday party and met this fabulous lawyer. She was dazzling, worked full-time, and had twins who were the same age as Sofia. I asked her how in the world she looked so good. Was it genes, or did she work out like crazy? I was working out an hour a day, but I was open to doing even more or switching to a different type of workout. I knew I was not going to look like my old self even though I wanted to, but it did bother me that people kept thinking I was pregnant again.

"I have a fantastic doctor," the lawyer told me.

"Oh, a weight loss doctor?" I asked.

But no—she gave me the name of her plastic surgeon.

I flipped a switch on the spot. I do not really even know why I was so against plastic surgery before. Maybe it was that I thought it was fake, but I am not entirely sure. But when I met this woman and she felt good about it, I knew I wanted it. I was not going to apologize for the fact that one of the things that motivates me and gives me confidence is looking and feeling fit. When my gynecologist gave me the okay to have plastic surgery, I got a tummy tuck and breast implants—AKA a mommy makeover. I have no regrets and consider it one of the best decisions I made for myself. It was like resetting the clock, and it just plain made me happy.

Fast-forward back to meeting with the second doctor about the pain in my chest. Once the doctor knew I had breast implants, he said, "Maybe they're leaking and that's what's causing this little pinched nerve feeling." He told me to check with my plastic surgeon to see if I was having complications from the mommy makeover.

I went back to my plastic surgeon, who I trust a lot because he is a very discerning doctor. I told him about the inconsistent nerve pain and asked him to check to see if the implants were leaking, if I was having an allergic reaction—anything.

After he examined me, he said, "This is odd. I've honestly never seen this before in thirty years of practice. I don't know what's going on, but based on what I'm feeling, I want you to see a chest surgeon. I think there's something growing inside your chest."

Of course, I took him seriously. I desperately tried to get in with the best chest surgeon in Austin, but it was a three-month wait. When I finally had my appointment, this chest surgeon did not even look at any of the things I had already done, which was everything short of opening up my chest during an operation.

"Your implant is leaking," he said matter-of-factly. He pointed to the door. "Go back to your doctor."

"Whoa, whoa, whoa," I said. "I already saw my plastic surgeon, and he told me to see you. I waited three months. I need you to take this more seriously."

But he was confident and insisted this was a closed case. I was furious. I could not believe I waited so long only to be turned away by someone who did not even look at my report.

Part of my stubbornness means I do not take no for an answer. When you know your body, and when you know something is off, you have to fight. I kept trying. I went to my best friend who connected me with her gynecologist friend. The gynecologist was willing to read my reports and explain the medical terminology to me in layman's terms because I did not understand what on Earth they meant, and everyone was giving me the runaround. A friend also suggested I schedule an appointment with a general surgeon instead of a chest specialist. The general surgeon could at least tell me whether they could or could not operate on me.

At this point, I could feel there was something hard in my chest. The pain was now because of this hardness, whereas it had previously been because my nerves sometimes felt like they were getting an electric shock.

The general surgeon asked me, "Do you know what a

desmoid tumor is? It's very rare, and it normally occurs in the bottom half of your stomach, but for some weird reason I think it's growing in your chest."

He told me not to panic and listed my options. I could go on medicine or go through chemotherapy, but he suggested just having surgery because of how much it had grown.

Just after I left the appointment, the gynecologist friend who agreed to look at my report called and said, "Hey Cindy, did anyone ever help you read these reports? One of the radiologists actually wrote on here that they suspect you have a thing called a desmoid."

I had my reports in hand since October, and now it was the holidays. The words and numbers were hard for me to process, but they were printed in black and white for the chest surgeon who turned me away on the insistence the pain was from my implants. I was livid, but at the same time, I was so grateful to have a friend who took time to read and demystify the report because I was in the dark.

I called my plastic surgeon and told him not to recommend that chest surgeon to anyone again. I would have rather the surgeon just turned me down, or better yet, referred me to someone else. He did not have to waste my time and send me on a wild goose chase, regardless of his reasons for not wanting to have me as a patient.

I elected to have surgery to remove the tumor in late March. I am very fortunate I could afford to pay my plastic surgeon to be in the room. On the off chance the implant caused the desmoid, I wanted documentation and photos so my surgeon could submit a case to the implant manufacturer. I get that things happen and I was not looking to sue anyone, but if something were to come out of this that could prevent another incident for myself or someone else, I do not want it to go unreported.

When my surgeon shared the photos, I asked, "What on earth is that? Is that my heart next to my implant?"

It was not my heart—it was my tumor. My tumor had grown to twice the size of my implant, and it was bigger than my heart. That is why I was in so much pain. The tumor was pushing against my chest and was trapped. It was so massive, it pushed my breast implant so far to the side that it was under my armpit. If it had grown any bigger, my doctor said it might have broken my rib cage.

FUN FACT

Perhaps I am a glutton for punishment, but I like to think of myself more as someone who loves to please my clients. When I found out the hardness in my chest was a tumor, all I could think about was the major events we had lined up for the year. We were understaffed, going through some turnover, interviewing to fill crucial roles, trying and failing to establish an executive leadership team, and now this?

The SXSW festival in mid-March is one of our biggest revenue sources, and this was on my mind when I was going over my treatment options in December. I was prepared for the worst, and I asked the surgeon, "Will I die from this?"

"No," he said. "You may be in a lot of pain, but you will not die from this."

"Great," I said, now thinking about my calendar. "I would like to schedule my tumor surgery for after South by Southwest."

I had not shared my health troubles with our team because I did not want to alarm them. I later realized they might have been more understanding about why I brought a new manager on board had I communicated the pressure I was under. We were also looking for a new head of sales because our point salesperson left the company around that time, so there was a lot of turbulence from these internal changes. Our team was fractured, and things were out of balance.

A lot of people who know about my illness ask why I did

not stop and pause everything. This goes back to my workaholic nature: I had to stay busy. If I was not busy, I would have gone down a rabbit hole Googling tumors and anticipating the worst. Though the risk of death from a desmoid tumor was low, there were enough random theories out there to scare me. There are three theories as to what causes it, but all three failed in my case. I am an outpatient at MD Anderson—the best cancer hospital in Houston—because they have no idea why I got my tumor, so I still need to be monitored.

As I moved past the rough patch with my health, we also moved past the rough patch with the company. After my surgery, I have actually been more relaxed and less likely to overcommit myself, and I do honestly believe I became a better manager because of my health scare. I was completely in the weeds when I started having pain, but dealing with my health crisis was the jump start I needed to make positive changes for myself and for Red Velvet Events. I had to learn that there are things I can control and things I cannot, as well as how to let go and understand what matters.

Before, I took control over everything because I felt I needed to in order to keep the company afloat. Now, I no longer need to because we have such a strong team in place. When you have a team you can trust, things can run without you if they need to. I am happy and healthy,

our team is happy and healthy, and we are able to move forward without me being the head of everything. I still work just as hard, but instead of spending time on the day-to-day, I focus more energy on the big picture. Where do I want the company to be a year from now? What do we need to do to get there?

.

WORKING STIFF

I started feeling pain again in December 2016, though this was different from my chest pain. Ever since I got the clearance to work out again after my mommy makeover, a trainer comes to my house three times a week, and I thought this pain was perhaps because of my exercises. I told my trainer we had to stop doing squats because my knees hurt. Then my foot started hurting, so I told my trainer we had to stop doing lunges. Then I was in so much pain, I told my trainer we had to stop working out altogether. I thought it was about lifting too much, so I went to see a physical therapist. But then my hand started hurting, followed by my elbows, then my shoulders. Soon I could not even hold my cell phone in my hand. My muscles felt hot, I felt cramped, and I could barely move.

I will be honest: I was not listening to my body. By the time the pain got this bad, it was May of 2017. I had let months pass since I first felt pain, in part because I misdiagnosed myself.

"Cindy, you need to go see a rheumatologist," my husband said.

A rheumatologist is an inflammation doctor. Since there was a three-month wait to see the best rheumatologist in town, I asked a favor from a friend who is personal friends with the doctor to see if I could get in sooner. I had a busy travel schedule, so this was a huge ask, but I was desperate. I was in so much pain, I was having trouble walking.

I was grateful the doctor was able to see me in June. After doing bloodwork, she confirmed I had rheumatoid arthritis. I had no idea what the heck that was. Isn't arthritis for old people? I learned that rheumatoid arthritis is actually a hereditary autoimmune disease.

The great news is that I am finally on treatment. The bad news is that this is something I am going to have to deal with for the rest of my life. On top of learning the importance of listening to my body, both of my health scares have made me realize I needed a more defined plan of what Red Velvet Events has to do as a company to get us to where the business could still be sustainable and continue without me one day.

YOU CAN'T HAVE IT ALL

Because event planning is a female-dominated industry,

the majority of people asking me how I balance home and work life are women. It is a bit of an eye-opener to think about, but while maybe one male student has asked me about that balance, the question has never come from a full-time working man. We still have a long way to go in our society. Women, by contrast, ask me the question in droves.

The million-dollar question: How can you be a professional working woman while taking care of everything at home, especially if you are also a mother? It's all relative. Remember, you are not just finding *a* balance—you are finding *your* balance. Balance is an individual preference.

My friend Amy is an Austin-based wedding planner whom I really look up to, and she deliberately refuses to take calls between 2:00 p.m. and 8:00 p.m. so she can take her kids to their sports team practices. Sometimes she even brings them to networking events. I am always amazed at how she pulls this off because I am not sure I could make that same schedule work.

How do I strike a balance that does work for me? For one thing, my husband and I make it a priority to eat dinner as a family, but we do not do it around our own table. We dine at restaurants all the time because I have learned that to make a meal I really enjoy, I would literally have to spend an hour or more on preparation and clean-up. Eating out

means we spend more, which results in us needing to earn more, but we also save a great deal of time and effort. And to be honest, I am not that great of a cook. We do not eat at fast food chains, and we have accidentally turned our children into foodies. My eight-year-old recently asked if the chef could add truffle oil to French fries. Seriously?

When family life comes into the equation, it becomes less about balance and more about integration. I want my kids to be proud of me and the life I have helped create for them. To do this, I need to set clear expectations. Kids do not necessarily know what is right, what is wrong, or what is normal, so the best we can do is clarify what *our* normal looks like as a family. I consider it important to explain that while our schedules might not allow us to do some of the things other kids do, they allow us to do plenty of other wonderful things like travel the world.

Take sports, for example. My daughter Sofia plays volleyball, but I have not allowed her to play other team sports like her friends because the training schedule is overwhelming. Her peers are into things like horseback riding, flag football, soccer, and swim team. I do not have the time to take her to and from multiple practices a week, let alone attend games and meets. While she is only entering sixth grade and is pretty fulfilled with sleepovers and playdates, we are getting closer to the age where we have to think about what kind of extra-curricular activities make her

a well-rounded individual for college. If she develops an intense passion for another sport, I will figure out how to make it work, but right now both my schedule and my husband's schedule make more activities impossible. I made an effort to set those expectations for her early on in order to avoid disappointment later, and we have some amazing friends who have been more than willing to help us drive our kids around to practice.

Women pile a lot of guilt upon themselves—especially moms. While I know on one hand I make decisions about balancing both family and career, I too have a nagging voice in my head bringing me down and telling me I am not being the best mother or the ideal wife. Lots of people might give me grief for catching up on extra work in the evening instead of spending time with my husband, or for not being the mom who is going to braid my child's hair before every game. But, heck, I do not even know how to French braid! If those things are important to you, then you should prioritize them. But I realized over time that my biggest highs in life are when Red Velvet Events is winning and our team is happy.

Some people ask why I do not make dinner or pick up my kids from school, and they are asking less out of judgment and more out of curiosity. They know I am my own boss and am in charge of my own schedule, so they wonder why I do not take some work off my plate. They do not

understand right away that this is what I signed up for. I could sell less and go down to having a smaller team, but I want to grow our business, not settle for less than I can accomplish.

Luckily, Scott and I are on the same wavelength. If he expected me to be home by 5:00 p.m. to make a fresh meal for the family, we would be having a very different conversation right now. I cannot emphasize enough the importance of being on the same page as your partner. We could both admittedly work a little less, but we are both extremely motivated people who love being productive and watching our companies progress.

Many women have guilt or hesitation about using nannies. When it comes to childcare, I have accepted I cannot do everything on my own. As much as I would like to be, I am not superhuman. Having help is a way for me to keep everything in balance according to my priorities and limitations. Just like I have a team at work, I have a team that helps us at home. I do what I want to do and outsource the rest, and that works for our family.

Over the years, we have used a combination of au pairs, part-time nannies, and a live-in nanny. It has been an interesting learning experience to figure out the best balance, and it is very personal. For example, though we liked our live-in nanny, that was the method that did not

work for us because we realized we preferred having our home just be our immediate family.

A more recent family concern I have been thinking about is what to do as my parents get older. I have noticed many people pivot their careers as their parents age. Some move to be closer to their parents' home; others relocate their parents to be closer to them. While I have asked my parents about moving to Austin, Houston has been their home for thirty-five years, and they are not interested in moving. While senior care for my parents is not an immediate concern—and while it is likely not a concern for those who are just getting started in their careers—it is worth being aware of so you can mentally prepare yourself down the line.

YOU DO YOU

What does balance mean to you? What are your career goals? What do you want your clients to take away from working with you? What matters most to you at home?

I am lucky to have Scott as a constant support system, and one thing I think everyone needs is a support system. This person does not have to be a romantic partner—just a confidante with a mind for business who has your best interests at heart. Scott helps me see things I am in denial about as well as the things I simply cannot see. With the

exception of the times he insisted I needed to charge more and hire a salesperson, he does not tell me what to do. Instead, he knows what to say to get me thinking. If you do not have that person in your life, find them!

Make an effort to identify your personal and professional goals and priorities, and communicate them to your partner, kids, colleagues, and clients. The things you value will likely change as you mature and gain more experience, and so will your idea of balance. Maybe when you were starting out, all that was on your mind was building a portfolio. Then a year later, you focused on hiring a solid and hardworking set of employees. Five years later, your work team is solid, but now you want to free up more time to focus on your family. Think about balance like planning an event, evaluating what still needs work.

Life loves to throw us off balance. As motivated as you might be to wake up and be insanely productive, you never know what could throw you off. Your kids could forget their sports equipment and have to be driven back home. A client could get fired, which causes you to lose an account. The list goes on. Every event planner needs to be a little spontaneous, but you also have to balance that with the right amount of forward-thinking!

A big part of finding balance is regulating yourself and

your life. Make moves, then check in to see where you stand—and be prepared to not always be prepared.

CHAPTER 6

#CULTURE

—

WHAT IS THE RED VELVET EVENTS CULTURE?

If I had to define the culture at Red Velvet Events, I would say it comes down to two phrases.

Here is the first: *Work hard, play harder.*

I expect everyone to give 200 percent to our clients and event partners—but when the hard work is over, it is time to celebrate our wins and each other. The culture we have built is one where we take extreme pride in our work and our city, and we elevate one another as we further our careers together. We place a high value on fun and happiness—especially in a notoriously stressful industry like event planning. Happy employees lead to a positive and productive company, and we need our team to be in good spirits when they interact with clients.

And here is the second: *Yes, we're confident, but we're damn humble.*

This is a testament to the fact that we are not only confident we will do the best job, but there is no task too small when it comes to executing the client's vision. If the client says, "Hey, I need you to go clean that toilet because the cleaning crew is stuck in traffic," then every member of the Red Velvet Events team should be prepared to grab some cleaning supplies, rubber gloves, and paper towels.

My number one pet peeve is when someone says, "That's not my job," or, "That's beneath my pay grade." I might not be the best at everything someone asks me to do, but I will try and do my best to do it. Event planning can be great fun, but it is not a walk in the park and we should always be willing to get our hands dirty.

HOW DID WE DEFINE OUR CULTURE?

When I first added other employees to Red Velvet Events during year three, I thought having a handful of general principles was enough for culture to define itself. As we grew, it became clear this was not the case. I thought I knew what culture was, but I had not done a great job at defining our values, and what was in place was not matching up to my wishes and ideals. I had also underestimated

how much each team member contributes positively or negatively to the company culture.

Sarah pointed out this problem was like a runaway train, and I was losing control. While I understood the values that I wanted in place, I was not making sure others understood or practiced these values as we grew. I was not in the office much anymore, so I was actually letting the people who had more presence in the office and who had been with the company for a long time define the culture. They were not leading by example, and I was not course-correcting it or commenting on it. This problem behavior set the tone and even resulted in turnover.

This was such a wake-up call for me. We committed to defining the Red Velvet Events culture more clearly and practicing it more actively. Sarah asked me pointed questions about what our culture really was and what it needed to be. I knew I wanted people to love their jobs and to want to be here. I knew I wanted us to work really hard to please our clients and to be committed to producing exciting, creative events. I knew I wanted us to celebrate and be able to laugh at our mistakes.

A common thread that emerged was creating happiness for our team and our clients. We never want to meet our goals at the expense of others. While businesses exist to make money, no amount of money is worth it if the

employees are miserable because people cannot play nice in the sandbox. Distressed or overworked employees are not excited to start the day. Having a motivated team is what keeps our company going and growing. This is what we needed to nurture.

Interestingly, mistakes and bad examples actually helped me define our culture by showing me what culture should *not* be. Some examples that came to mind were internal, some were from a handful of challenging clients we had worked with over the years, and some were from the business world at large. Just as I like to keep my finger on the pulse of what is happening in the world of technology, I also pay close attention to practices and trends in business. This helps me learn from industries outside of event planning. Not only is it an opportunity to examine stellar practices from positive work cultures, but it also illustrates why unhealthy practices are so problematic.

For example, I once had a team member break a commitment for an out-of-town event where she was the lead planner because she accepted a job at a big corporation that required her to begin training on the same day as her assigned event. She quit the day after I had surgery to remove my desmoid tumor, and we were given less than two weeks' notice. I knew the hiring manager because the corporation is a Red Velvet Events' client, so I called her. I had accepted that the employee was leaving, but

because not honoring her commitment really left us hanging, I asked the manager to reconsider her start date. The manager gave me a hard no and said the employee would lose her offer if she did not start that day.

The lack of principles involved in this whole dilemma really bothered me, and it was not an isolated incident. While I love doing the client's events, and while any of my competitors would love to have them on their client list, they have a troubling work culture that I struggle with. Another example of this problem is when something goes wrong at an event and they berate our team. This is beyond the normal situation of providing negative yet constructive feedback when things go awry; it is public humiliation. No one deserves that, even if the frustrated party is under a lot of pressure. It is also a counterproductive approach that causes new problems instead of solving existing ones.

Perhaps they feel they have the leverage to behave this way because they are so big. That is not the kind of culture I aspire to build, and experiences like that clearly distill the importance of honoring commitments, of respecting business partners and their commitments, of offering constructive critiques, and of parting ways on the best possible terms.

We have a lot of employees whose first full-time job is Red

Velvet Events, and we also have other people who join the company without having had the pleasure of working events of any kind. Some team members will have a lot to learn and will make mistakes, so we knew we wanted to foster an environment of learning and coaching to set our team up for success. Our management style has a huge influence on our culture, so it was important to clearly identify behaviors that create toxic environments as well as behaviors that would help us better lead by example.

Here are some of the problematic behaviors and principled behaviors we identified as we brainstormed:

- We do *not* want anyone on the team to berate, demean, or point the finger of blame with comments like, "Why did you do that?" and "Don't you know better?" Such comments only exacerbate problems.
- We do want to foster a culture where problems are addressed thoughtfully and constructively and where team members are coached through mistakes.
- We do *not* want an environment where people focus only on personal career growth and on looking good.
- We do want to foster a culture where people take others along as they climb up the ladder, where people work together and feel proud of collective achievements, and where people understand that we are—and have always been—a team.
- We do *not* want a workplace where people are afraid

to speak up about problems or suggestions or where they feel undervalued.

- We do want to foster a culture where employees feel comfortable expressing ideas and voicing concerns, where they feel valued, and where they feel their input matters.
- We do *not* want a culture where people believe being a boss means leaning on authoritarian tactics and inspiring fear.
- We do want to foster a culture where leaders inspire enthusiasm and depend on goodwill. Anyone can be named a boss, but not everyone is a leader.

The more we discussed how we wanted to define the culture at Red Velvet Events, the more I realized we had to make more changes. The reason some people were not setting the right tone or leading by example was because they were not the right culture fit, and this created an authenticity problem for the company. We had told people we were one thing, then delivered something else, sending mixed messages to our team. That inauthenticity is a cancer to the culture and cannot be ignored. We needed to resolve this by finding the right people.

HOW DO YOU CULTIVATE CULTURE?

We did not clean house all at once, but we did go through phases of shifting into our new culture. We communicated

our new mission to the team, and when we had talks with individuals who had been causing some of the cancer in our organization, they chose to leave because they were not aligned with the same vision. Even smart, talented, driven professionals can be an improper fit for your business if they do not understand or represent your culture. You can tell someone again and again what values your company represents, but they might not have the history, the experience, or even the inclination to embody those values. We also focused on hiring new people who would embody our culture.

We have learned that it is so much more important for us to hire someone based on whether or not they are a good fit for the Red Velvet Events culture than for their tactical skills. Tactical skills are still important, but they can be taught. If someone is a C in Excel but an A in culture, they would most likely still get the job. If someone is an A in Excel but a C in culture, they would not make it far in the interview process.

Interviews are our primary method for identifying who is a good culture fit and who is not. We are very candid about the fact that our interview process is lengthy. We would rather take extra time up front to ensure we have the right person than have to go through the time-consuming, expensive process of bringing a bad fit onboard and having to let them go three months later. Even if a candidate

comes highly recommended to me by someone I trust, they still have to go through our process.

We hope to have an idea of how a new hire will grow with the company after a few months, but if for some reason that connection is not happening, we reexamine the interview process. *What broke down? What did we not ask to figure this out?* Problems related to having a poor culture fit are largely preventable, which is one reason why our interview process has gotten lengthy.

Because we already know people will respond to common questions like, "What is your biggest weakness?" with common answers like, "I'm too detail-oriented," there are certain personality questions we now ask to get a better sense of whether or not the person will fit in with the culture. Every question is very intentional and does not have an empirically right or wrong answer. We expect to hear different things from candidates. Outside of having similar taste in food, I am nothing like either of my sisters, and we would probably all answer these questions differently. We are looking to see how people respond, particularly because we are often on the receiving end of uncomfortable or last-minute requests from clients, so we need to have a sense of how team members would respond to such requests.

It is also imperative for people to love events to work in this

industry! Even if they have never worked an event before, they should still be excited about diving into the field. If someone is interested in our company because we have awesome benefits and have a great social media presence, I would tell them those are not the right reasons to join. Even if someone is on the operations team and does not go on site to do events, this job is still all about events. The bud will come off of the rose if you love the benefits and culture but dislike the industry and the events themselves.

If someone feels like they cannot wait to wipe their hands clean of an event, or if they like the partying part but not the hustle of the work, then this job is probably not a good fit. Every event we touch gives me butterflies, much like when someone is excited about a second date or nervous before a performance. That excitement comes from the thrill of seeing the event come together. I want people on our team to rise to the occasion and feel that thrill, too.

HOW DO WE STICK WITH OUR CULTURE?

Once we defined our culture and successfully implemented it, the question became, "How do we stay true to our culture as we grow and evolve?" Many of the things that made sense for our business when we only had a few team members no longer made sense as we grew to eight people, then sixteen, then twenty-five. The bigger the company, the more variables and the more potential for

chaos, so it is important to find ways to keep your values alive regardless of how your company grows.

Luckily, I have found that the best way to stick with your culture is simple: **Love what you do and love who you do it with.**

The culture at Red Velvet Events has changed over the years, and this change has been for the better. There are still stressful days because it is a stressful industry, but in the grand scheme of things, people really love their jobs and the environment we have created. Once you have a team together that understands, practices, and respects the culture, you keep it alive by putting conscious effort into ensuring the happiness of your team. When people love what they do and love who they do it with, it simply becomes easier to practice the things you value and stay inspired.

We do this in a number of different ways at Red Velvet Events. Sometimes it is as simple as making sure employees get to enjoy events we participate in after the hard work is done. The Austin City Limits (ACL) Music Festival is one of our city's biggest events of the year. It is produced by C3 Presents and is held two weekends in a row in autumn. Typically, we have client events prior to the first weekend or in between the two festival weekend dates. It is an intense time, which means we need all hands

on deck. Normally, our policy is to always honor requests for paid time off (PTO), but the two exceptions are that we require everyone to be available for SXSW and ACL. People can still ask for PTO during these dates, but we have to wait until closer to the event dates to evaluate whether our staffing needs are met before we can grant any requests. If we power through our client events and see that we can afford to have a team member out of the office early, then we are happy to grant them time off to enjoy the festival. We work in a fun industry in a vibrant city, and it is important to us that we get to take advantage of that after our client needs are met.

We reinforce our values in a number of other areas, such as providing benefits, showing appreciation, and celebrating. Because our culture is all about our people, we weave a lot of our personalities into the ways we reinforce it. Our team understands how much I love to experiment, so when they think of something new and different that could benefit our culture or help enhance the team's experience, they will bring the idea to me and we might try it out.

While I cannot pull back the curtain and reveal all the ingredients of the secret sauce that go into our culture, I am happy to share a handful of examples of how we keep the love for our company and for each other alive!

BENEFITS

It is important to me that team members feel encouraged to balance their personal and professional lives. At Red Velvet Events, we want our team to maximize their personal time when they are not working, so we recently changed our paid time off policy from two weeks to unlimited. A risky move, some would say, but I have trust in our employees. So far, it seems to be working!

We provide full medical coverage even though it is not a requirement for a smaller company like ours. As soon as we got to six employees, we issued a stipend to cover health costs. Then once we got bigger, we decided to buy a group plan and cover it at 100 percent. I think that is the right thing to do as a business owner.

I also think this country has an unfortunate view on health care costs, which is why I chose a high-deductible health plan (HDHP). You automatically get two doctor visits a year, and the plan rewards employees for staying in good health. The plan also does not jeopardize employees if something catastrophic happens to their health. The plan has a cap where people will never spend more than $3,000 on medical benefits for the entire year, and I cannot stress enough how this has helped us compared to a PPO. If I were on a PPO, I would be paying 20 percent of my hundreds of thousands of dollars in treatment at MD

Anderson. With our HDHP, I only have to pay a fraction of this thanks to the cap.

We also cover the costs of networking expenses for our team members. Outside of hotels, most folks in this industry avoid the additional expense and expect their employees to network on their own dime. But because networking was so instrumental for me when I was growing the company, we want to encourage our team to learn in the same way, so we make sure their costs are covered.

SHARE THE LOVE

Appreciation is so important to me. I have very few mandates, but from day one I have made it a requirement to write handwritten thank-you notes to our clients, partners, and internal team members. If someone received a gift, if we were invited to visit a site, or even if it was just a minor favor, I want the other party to get a handwritten note. Not an email, not a text, but a thank-you note on custom stationary. Our design team recently created three custom designs for our thank-you cards, and they are amazing. The cards feature playful puns, such as one with a picture of a taco on it and a message that says, "Taco 'bout awesome." It combines thoughtfulness with fun to express our creativity.

Something that has been an awakening for me as a leader

is learning the importance of helping others achieve their goals. I really do believe in karma, and I think this is something leaders should do without seeking a pat on the back. Getting credit does not matter. It has been said that people will forget what you said and what you did, but they will never forget how you made them feel. I think that is so true.

In the last decade, this realization has been important for my life and for Red Velvet Events. Yes, we want to make money, but we also want to deliver great experiences that make our team and our clients happy. While there was never a time when I was primarily concerned with getting credit, this awakening put the attitude of genuinely wanting to help into clearer focus, making it easier to weave into the culture. Better understanding this principle helps us commit to our client's objectives and commit to our team members, and we embody appreciation for them by helping them achieve.

To show appreciation internally, we also use an employee engagement platform called YouEarnedIt, which is a start-up based in Austin. The system allows the team to thank one another in genuine ways. Team members can send points to someone along with a message recognizing them for their efforts, and points can be exchanged for rewards like gift certificates, clothing items, and other fun stuff. Red Velvet Events covers the expense, so it is a fun way for our team to show their appreciation for one another.

This was more of a personal show of appreciation than a company initiative, but I had one team member who started with me when the company was nothing. I could not afford to hire her, but I did not want to lose her and convinced my husband to help me hire her part-time. He and I split the cost of her salary for a few months until we closed a big deal that allowed me to bring her on full-time. She grew to be an extremely dedicated team member who flourished at making our clients' events a success. When I learned she was getting married, I really wanted to get her something extremely special. I used my own money—not the company's—to pay for half of her honeymoon because I knew she was going somewhere expensive and exotic, and it was costing her more than she thought. Because of our history together and her role in helping build Red Velvet Events, I really wanted to help her enjoy her trip without stress. I do have a bleeding heart, so I have to be smart about what I ultimately choose to help out with, but I always want to do my best and help out if I can.

CELEBRATE!

You have to celebrate! This is so important: Do not forget to celebrate milestones when you cross them! Whether in business or at home, give yourself time to feel proud of achievements both big and small. Celebrating wins helps you and your team stay on track and stay motivated. I love surprises and adventure, and I love to experiment

with new things, so many of the ways we celebrate reflect those parts of my personality.

Our Operations team is Red Velvet Events' support unit across the board and forms the backbone of the company. In 2017, we gave them a set budget to do Random Acts of Fun. Instead of doing the same thing every month, we let them get creative and organize totally random surprises for everyone. One time, we went roller skating as a group. Right after SXSW, they brought in a masseuse to give the team thirty-minute massages in one of our conference rooms. Recently, they brought in acai bowls from Juice-Land, which is our local smoothie spot.

FUN FACT

Red Velvet Events has three different divisions:

- Our **Operations** team oversees accounting, careers, human resources, office supplies, and facilities.
- Our **Business Development** team handles sales, all of Red Velvet Events' marketing initiatives, and creative.
- Our **Professional Services** team is made up of our program managers, associate program coordinators, transportation coordinator, and any interns hired to help plan.

Whenever we have an internal activity, the activity in question is chosen because it supports a part of our cul-

ture. The Random Acts of Fun help remind people why we love working here and that we are a work family. We have many people who relocated to Austin to start their careers—several of whom relocated just to work for Red Velvet Events. It takes some time to build a social circle, and spending forty hours a week or more at work means that it is incredibly important for everyone to enjoy their coworkers. I do not expect people to hang out twenty-four seven, but I do think it is important to get along. If we do not genuinely enjoy and appreciate each other's company, then we have not brought the right team together.

There was another time when we were looking to give the team some stress relief, and we thought it would be fun to have the team break a piñata full of candy and miniature alcohol bottles. Sarah accidentally stumbled across what she considered to be the perfect piñata.

She came back to the office with a piñata of Wyldstyle, the female character in *The Lego Movie*, and she asked me, "You know who this is, right?"

The character looks a lot like me, and I could see what she was getting at. I even showed a picture to my husband, and he thought we had a custom piñata made of me.

"Did you want that because you think the team would actually enjoy beating me up?" I asked. I am a kid at heart,

so I was okay with it, but I wondered if the team was actually going to hit it.

"Oh, yeah," Sarah said. "I think they're going to hit it."

When we brought it out, everyone was shocked—and they wound up having a blast! I think it is important to have a culture where you are able to laugh at yourself.

When it comes to rewards, I used to dole out perks to individuals for hard work, but this contributed to an every-man-for-himself attitude. Not only that, but it rewarded the self-promoters while failing to recognize the true team players. After reflecting on our problems while redefining our culture, we realized it would be much better to reward based on team efforts. This change has drastically boosted morale.

I love to inspire people to push past their limits. One thing that has helped me do this in my own life is not just setting goals, but also setting stretch goals. Our team members receive bonuses for meeting our company goals, and we also have a stretch goal where the reward is a surprise trip. I plan this trip without any help because I want the location to be a secret for everyone. Our first surprise trip was to Cancún, Mexico, and the second trip was to Costa Rica. Should we meet this year's goal, the team will be headed to yet another mystery destination. All they know is that the trip requires a valid passport.

For the first two trips, everyone was allowed to bring a plus one. This time, I sent everyone a survey asking, "Would you rather have a more exotic trip that is farther away and not bring a plus one, or would you rather have a less expensive trip and bring along a plus one?" I love adventure, and I wanted to experiment with giving the team a choice in a way that added excitement and suspense. The anticipation keeps people on their toes and gives everyone something to really look forward to, motivating them to work hard and get to the next level. If we go big, I like to reward big.

Meeting the stretch goal is not easy, and I worry sometimes that there will be intense disappointment if I choose a goal we cannot meet. Our stretch goal for this year is a higher revenue number than we have ever done before in our entire history. It is meant to be uncomfortable and difficult. At the time of writing this, I do not yet know whether we will make the stretch goal and go on the trip, and I do not know exactly when we will go if we do meet it. At the end of the day, setting risky goals is part of our culture, too. We did not grow Red Velvet Events by choosing to be comfortable. We grew the company by betting on ourselves, betting on our team members, and embracing the risk.

If you would like to find out if we meet our goal this year, you can follow us on Instagram @redvelvetevents!

#OUTPLAN #OUTPLAY #OUTPARTY

—

SHOW OFF WHAT YOU'VE GOT

When I accepted the gig that became the Great Margarita Fiasco, I took on a beverage and catering position when I could not even set up glasses properly. As creative individuals, we always want to experiment, but it is also vital to know when we are making things more difficult than they need to be because something is totally out of our wheelhouse.

On a larger scale, this does not mean you should stop taking risks that will grow and expand your business. It means when you feel ready to grow in a new area, you

should find the right resources to do this without causing more problems than you are solving. At Red Velvet Events, we wanted a creative team in the company, so we hired a set of employees who were experts in a field we were not. Now our creative team differentiates us from other companies, but only because we put enough time, effort, and resources into making that team one of our major assets.

ALWAYS BE LEARNING

If you follow me on social media, you may have noticed one of my favorite hashtags is #AlwaysBeLearning. I am still a bit of a nerd just like I was as a kid, so this is a life motto—but it applies to business, too. Being critical, attentive, and curious are powerful qualities, especially when it comes to evaluating what does and does not work well for your business.

Earlier, I talked about both hiring and firing. If I am in a position where I have to let someone go, I do not just wash my hands of them and forget they ever worked for Red Velvet Events. I cannot help but question where it went wrong. *What did not work? Why were they not aligned with our company culture and/or processes? Is there anything we could have done differently? What am I missing? How did I fail them?*

If you want to excel, you cannot be the person who does

the bare minimum. Reflection should be a structured exercise. Write down your successes and failures and you will inevitably see patterns emerge. Dig beneath the surface, analyze, and correct your mistakes. It is like the scientific method. Make an effort to be as objective as possible. If we have had to let someone go, we assess what went wrong, what kind of person we need the next time around, and what needs to change on our end. We work to isolate the variables as accurately as possible in terms of what triggered problems, and we use that to inform our hiring process.

Though rare for us, Red Velvet Events has gone through occasional lulls even after our valley-of-death years when I was initially building Red Velvet Events. I am extremely grateful for the fact that Red Velvet Events has been consistently busy, and because of that we have never had to chase sales. We have never done big email campaigns or radio spots or print ads. We are less about general outbound marketing and more involved in making real, face-to-face connections. What is a slow period for us might be another CEO's dream, and I make sure I value that every day. Since I do not take our success for granted, I never want to rest on my laurels. So, if I get a gut feeling that things are a bit slow, I immediately go into Nancy Drew mode.

When these slow periods bubble up, I take the opportu-

nity to do some analyzing. I will stop and question if we have been doing something to change our usual pattern, and that something is crucial to identify. Since we are a word-of-mouth business, maybe we had not been putting ourselves out there enough and got fewer recommendations and referrals. On one occasion, I scrutinized three years' worth of events and asked myself why we had not heard from certain clients again. *Did we lose them? Did they stop doing events? Did they get acquired? When was the last time we were in touch?* If we had lost them, I wanted to know why, and what we could do to get them back.

I am a huge proponent of collecting feedback from clients, partners, and peers. Checking in with other perspectives is the key to learning what you are good at and pinpointing areas that could be improved. After every event, we do a post-con (post-conference) where we ask people what they liked, what they did not like, what areas may have really frustrated them, and whether or not there are any other areas where we could have really wowed them. There are always events that do not turn out exactly as you or the client envisioned, and feedback is especially important on these occasions. That degree of feedback might sound like we are gluttons for punishment, but what we care most about is pleasing the clients and learning from each experience. There is always room for improvement, but only if you understand where exactly this room is.

SET, SHOOT, AND SCORE

Coming from a person who made Excel spreadsheets for fun, it should not be too shocking that I am also the kind of person who always regularly sets goals and timelines. I only recently realized how fundamental this personality trait is to the way I run our business. This behavior drives success far beyond simply wandering through life, expecting good things to just fall into your lap. Good things will come to those who know what they want and are realistic about how they are going to get there.

When it comes to goal-setting, big goals are hard to hit, so start small and work your way up. When starting Red Velvet Events, I gave myself a goal of one year to build experience before I reapplied for other jobs. I dreamed of making $100,000, but I knew that was not actually realistic since I was still figuring what the heck to even charge. During year one, the company lost $12,000. That amount is actually pretty minimal, so I considered that to be a success. As the deadline approached and I realized I loved what I was doing, I decided to keep going and gave myself another two years. Going into my second year, I wanted the company to make at least $25,000 to pay off the previous year's loss and reinvest the profit back into the company—and I did it. For year three, I doubled that goal to $50,000, and we met that goal, too. By year four, we were on a roll, and $100,000 did not seem so unattainable. And guess what? We did it! I am very pleased

with where the business is now, so clearly, we are doing something right.

That does not mean the path was paved in gold. Those numbers did not magically double themselves without a lot of hard work and structured processes. During stressful periods early on when I worried we were going to have to shut down, I set bite-sized goals on a three-month time frame. If I did not see a positive change in that time period, then I knew I needed to move on to Plan B.

Sometimes, these small goals wound up being big game changers. One year, I lost a long-standing employee. As a company, we were not hitting our stretch goals, so I could not afford to pay her what she needed. She quit, and not long afterwards, another employee moved away. The company was left with three people: myself, Sarah, and one other employee who had been with us for less than a year. Three people was not enough to build the business I had envisioned. We were not making money, business had dried up, and I was starting to panic. Around this same time, everyone was telling me to hire a salesperson (in reality, they had been suggesting this for a while...see Chapter 4), but I was convinced we could not afford anyone. If you had asked me how I felt about the business at that point, I would have told you we were going to shut down.

Cue my husband, the voice of reason. He encouraged

me to come up with an attainable goal and give myself a short time span to achieve it. I did a quick calculation of how much money I could afford to lose in a year and took a leap of faith. Just like during my first year of business, I gave up my own salary. I did the math and accepted that I was in a lucky position because I could go without paying myself for a year and still be okay. I used the money to finally hire a salesperson to join our three-person team. She was driven and hardworking, and she immediately began closing deals we desperately needed. Suddenly, we were hiring like crazy. Within a year, we managed to completely turn around what had once looked like a bleak future.

I still use the strategy of setting small goals today. With every small win, I learn more about where we are going. These smaller goals make it so much easier to tackle one thing that can reenergize your work. When you allow yourself room for experimentation, knowing in advance that not every solution will work, even your failures become successes. I also cannot stress enough how my stubbornness helps drive me forward with a determined but realistic mindset and a firm grip on what I am able to accomplish. There has not been a time I can remember when I have given myself the freedom to experiment with smaller goals and it has not worked out in my favor.

The key to remember is that as an entrepreneur, you have

to go through periods of necessary discomfort. There is a saying that goes, "If you think it's easy, you're doing it wrong." I definitely agree. If you are always comfortable and running on autopilot, you are not pushing yourself nearly as hard as you need to if you are aiming to achieve the breakthroughs you want.

Event planning is for hustlers. This is not an industry where you can afford to be apathetic. Looking back, I can clearly see there were times when I made decisions out of fear, when I could have been more daring with the goals I set for myself. Now that I have more experience and Red Velvet Events is thriving, it is easier for me to see that fear for what it was. Some of the fear you will experience is part of pushing yourself out of your comfort zone, but you still have to find the sweet spot and make sure you are not letting fear keep you from pushing yourself to your true limit. You have to trust your potential when you take a leap into the uncomfortable.

PERSISTENCE COMES FROM WITHIN

I have always had a strong internal drive. My parents immigrated from Hong Kong, and because I was first-generation, my mother was set on me being an honors student. The idea of "face" is a Chinese cultural obsession. We have it to a degree in the U.S. when it comes to concepts like "saving face," but it is nothing compared to

how this is ingrained in Chinese culture. Children who prosper by doing well in school project a good face on the whole family. Though my mom's parenting style was not as extreme as the Tiger Mom stereotype, she did care that I worked hard to become smart and successful. At one point after sixth grade, she made me get all new friends because the kids I had befriended at my new junior high were not honors students. That was actually very sad and on the more extreme end for her, but she was truly worried they were going to hold me back.

I was not fully aware of this as a kid because I always loved to work hard and learn, but this attitude shaped my work ethic and led me to where I am today. I have never been one to settle for just getting by because being mediocre is not on the menu. I do not wake up each day and aim for average. When you take pride in your work and accomplish something great, the results are so much more gratifying than when successes are served to you on a silver platter. Although I have battled my fair share of pressure, I am grateful I have always been encouraged to strive for greatness.

I realize not everyone has this same fire inside them, but I do believe that deep down, even aimless and unmotivated people dream of being successful in a way that is relevant and applicable to them. Each person's definition of success, just like their idea of balance, is individual. Work toward your own goals, not someone else's.

FITTING IN IS OVERRATED

In this industry, a sense of individuality is crucial. I always had friends when I was younger, but I never fit neatly into any of the cliques that develop among teens. My elementary school in the outskirts of Houston was predominately white, and my parents intentionally raised us in a non-Asian neighborhood of Houston. When you are Asian and you live in Houston, people immediately think you must live in Sugar Land or Bellaire, both of which have large Asian populations. When my parents moved from Hong Kong and started a family, they wanted us to get integrated into American culture as quickly as possible, so they settled in Jersey Village in northwest Houston.

By the time I went to school with other Asians in middle school, they insisted I was not really Asian because I did not have any Asian friends. I did not roll with the cheerleaders, the popular crowd, the athletes, or with the Dungeons and Dragons nerds. I was never the class clown. It was always just me. I had friends, and I certainly was not shy since I had been getting in trouble for talking too much since the first grade! The point being, I figured out early on that I was not going to be defined by others. I was just me, just Cindy, and I was going to do what I wanted to do.

No matter where you come from, where you think you fit in, or whether you fit in at all, the one place you will always belong is in your own skin. Own your individuality.

WORK HARD, PLAY HARDER

"Outplan. Outplay. Outparty!" is more than our company's tagline. Not only does it have a great ring to it, but it reflects what Red Velvet Events is all about. Every step we take in our business is geared toward these three things.

Given my love for logistics, keeping busy, and organizing things, "outplan" is a big part of my personality and the company. "Outparty" is also pretty clear because our goal is to produce events people love to be a part of and will never forget. The word "outplay" is a little more surprising at first because it carries a special double meaning.

We work hard, but our company loves to be playful and positive. We seize the day. Event planning is a fun industry—too fun to not take advantage of it. Despite being constantly busy and facing demanding situations, I always check myself to make sure I am enjoying what I am doing. If I am not having fun, what is the point? One great perk of being in this industry is that Red Velvet Events gets invited to lots of restaurant openings as well as open houses by venues eager to show off their spaces. Not taking advantage of this would be a huge missed opportunity. We get to network, try out incredible new food, explore and support the city we love so much, savor experiences, and have fun with friends. This business cannot just be about putting my head down and staring at spreadsheets.

The Red Velvet Events team loves to go above and beyond to make our clients happy. We had a great year last year, even though we dealt with our fair share of employee turnover challenges. To thank everyone who made our success possible, we rented out the Austin cinema Alamo Drafthouse, invited all our partners and vendors to an ugly Christmas sweater party and screened the movie *Office Christmas Party*. Did we have to do that? Of course not. Did we want to? Absolutely. It was so much fun!

Not only does "outplay" mean having the most fun, but it also means we go above and beyond to outperform. I am extremely competitive. If I am going to pursue something, I will strive to be the best in the business. This is my fuel, and I am so lucky I get to apply that to something I love to do.

If you want to have a thriving event planning company, I hope outplanning, outplaying, and outpartying can be your fuel, too. Whether you have years of experience or are navigating this industry for the first time, I hope this book leaves you feeling empowered and inspired to take your business to the next level. I am living proof that you can build and run the event planning business of your dreams.

APPENDIX

EVENT PLANNING
TERMS TO KNOW

- **ADMC** – Accredited Destination Management Company
- **ADMEI** – Association of Destination Management Executives International; visit www.admei.org
- **AV** – Audio Visual
- **BEO** – Banquet Event Order
- **CAD** – Computer Aided Design; commonly used in lieu of a floor diagram
- **CMP** – Certified Meeting Professional
- **CSEP** – Certified Special Events Professional
- **CSM** – Catering Sales Manager
- **CVB** – Convention & Visitors Bureau
- **DMC** – Destination Management Company

- **DMCP** – Destination Management Certified Professional
- **F&B** – Food & Beverage
- **HSMAI** – Hospitality Sales & Marketing Association International; visit www.hsmai.org for more info
- **ILEA** – International Live Events Association (formerly ISES); visit www.ileahub.com for more info
- **ISES** – International Special Events Society (now ILEA)
- **LOI** – Letter of Intent
- **MPI** – Meetings Professional International (formerly Meeting Planners International); visit www.mpiweb.org for more info
- **OOO** – Out of Office
- **PAX** – Passengers
- **PTO** – Paid Time Off/Personal Time Off
- **RFP** – Request for Proposal
- **RTFM** – Read the F#@%ing Manual
- **SXSW** – South by Southwest; visit www.sxsw.com for more info

CINDY'S MOST-USED ACRONYMS

- BE/C = Because
- BTW = By the way
- CXL = Cancel
- CYL = Cindy Y. Lo
- DYK = Did you know
- EOB = End of business
- EOM = End of message
- F2F = Face to face
- GSD = Get sh*t done
- IG = Instagram
- IRL = In real life
- LMK = Let me know
- THX = Thanks

ACKNOWLEDGEMENTS

I don't even know where to begin. There are a lot of people I need to thank, especially since this book project started more than three years ago. Thank you, Sarah P., for helping me get this started on what seems like only yesterday. Thank you, Larisa, for proofing the first pass of this book. You were there for me then when I had this crazy idea and are here with me now to relive it all.

Thank you to our RVE Family. I am so grateful for the team we have at Red Velvet Events. Each and every team member puts forth their best for our clients. Without them, we would not be where we are today. So, thank you to SYL, RNP, LBR, ABA, CAH, CSF, JMS, JLF, KAT, KFB, KDB, KLD, KMK, LJG, LYL, LIZ, LMB, MJB, MAP, REG, SEO, TNZ, VIC, and VBR. And to all the team members who came before them and helped build Red Velvet Events, my eternal gratitude—especially to Pam, Sara, and Jennifer.

You three joined Red Velvet Events at a time when there was a just a glimmer of hope.

I have the best support network a female entrepreneur could ever ask for, and because I know I may have forgotten someone here, I just want to shout, "THANK YOU!" from the rooftop. Thank you to every one of you for believing in me and giving me a chance. I hope all of you know who you are when you read this, and I hope I can continue to pay it forward to everyone who has helped me along the way. And a special shout-out to my ILEA, MPI, ADMEI, HSMAI, SITE, Trilogy Alumni, and UT family.

Last but not least, thank you to my family. To my parents, thank you for raising me right and always giving me opportunities you did not have. I love you very much, even though my Asian personality prevents me from showing you every day. To my in-laws and relatives, thank you for being so supportive of my workaholic nature and never making me feel bad for wanting to provide for our family. To my children, Sofia and Holland, thank you for being a constant source of inspiration and laughter, and for making me a proud mom every day. And to Scott: I recognize it is not easy being married to me, especially on those days when I just want to talk early in the mornings, yet you love me just the same on our good and bad days. I love you for that! You are my number one cheerleader, and I cannot tell you how proud I am to be your wife.

ABOUT THE AUTHOR

———

CINDY Y. LO DMCP is the founder, owner, and chief event strategist of Red Velvet Events, a Global DMC Partner (RVE) and an international award-winning, full-service creative events agency. A graduate of the McCombs School of Business at The University of Texas at Austin, Cindy began her career at Trilogy Software, a tech startup, before launching RVE as a solo endeavor in 2002. She is a self-taught event professional with an eye for detail, a flair for design, and a finger on the pulse of all things digital. Texas-born and raised, Cindy lives in Austin with her husband and two children.